Outpourings of an Art-Loving Friar

WILHELM HEINRICH WACKENRODER

AND

LUDWIG TIECK

Outpourings
of an
Art-Loving Friar

Translated from the German and
with an Introduction by
EDWARD MORNIN

FREDERICK UNGAR PUBLISHING CO.
NEW YORK

Translated from the German
Herzensergießungen eines kunstliebenden Klosterbruders

Copyright © 1975 by Frederick Ungar Publishing Co., Inc.
Printed in the United States of America
Designed by Irving Perkins
ISBN: 0-8044-2958-8 (Cloth)
 0-8044-6962-8 (Paperback)

Contents

OUTPOURINGS
OF AN
ART-LOVING FRIAR

Introduction

Outpourings of an Art-Loving Friar, which appeared in 1796 (dated 1797), was the first work of German literature to which the label "Romantic" has been unanimously applied. Earlier writings, by authors such as Ludwig Tieck, August Wilhelm Schlegel, or Friedrich Schlegel, were either immature productions or conceived from a standpoint from which their authors departed to a greater or lesser extent in their later, Romantic phase. How appropriate that this first masterpiece of a new and youthful movement should have resulted from the efforts of two such young men! Wackenroder and Tieck were only twenty-three years old when *Outpourings* appeared. The fragile Wackenroder—the work's initiator and principal author—was fated to die a little over a year later, the tragic victim, it will be seen, of a typically Romantic conflict between his artistic inclinations and his filial duties.

Outpourings, to be sure, was not altogether without precedent, for many of the work's ideas can be traced back to pre-Romantic antecedents. Yet its authors not only adopted, but modified and transformed the views of their predecessors, thus creating a unique and original work. So extraordinarily fruitful did some of its ideas prove to be, that *Outpourings* must be regarded as a work of rare documentary value. Even where an attempt to show its direct *influence* would be impracticably complex, if not misguided, it illustrates trends extending far beyond the limits of Germany, or of literature alone, or of Romanticism in a narrow historical sense.

The authorship of individual essays in *Outpourings*, though probably impossible to establish beyond all doubt, has been substantially settled at least.[1] Wackenroder certainly was the moving spirit behind the work. It was he who, in 1796, showed Tieck a number of essays on art and music which he had written and then agreed to let Tieck publish these, originally intended only for intimate friends, after Tieck himself had added to them. Tieck, ever a virtuoso of style, managed successfully to conserve the peculiar flavor of the original. Yet it cannot be denied that he offended the spirit of universal applicability and timelessness of Wackenroder's work, notably by imposing upon it an excessive Catholicizing tendency (in the "Letter from a Young German Painter in Rome to His Friend in Nuremberg") and by his frontal attack on Ramdohr and dedication of the essays "exclusively to aspiring young artists" (in "To the Reader of These Pages"). Also wholly or in part by Tieck are "Yearning for Italy," "A Letter from the Young Florentine Painter Antonio to His Friend Jacobo in Rome," and "The Portraits of the Artists." All other contributions are by Wackenroder, though collaboration on individual essays cannot be discounted. The work was received and made its impression as a totality, however, so that the question of individual authorship need not concern us further here. To all intents and purposes, these epoch-making essays were the work of the fictitious Baroque friar, an appropriate mask assumed by the modest and retiring young Wackenroder behind which to conceal his identity.

Despite differences in social level, Wilhelm Heinrich Wackenroder (1773–98) and Ludwig Tieck (1773–1853) came from not dissimilar backgrounds. They were born

within a few months of each other in the same city of Berlin, where they became firm friends when attending the same high school, the Friedrich-Werder-Gymnasium, which was one of the leading Enlightened educational institutions in Germany at that period. Their fathers, both of authoritarian mould and deeply concerned for the education of their children, may be regarded as fairly typical representatives of Berlin society, which was then a stronghold of German Enlightenment. Though men of goodwill and moral integrity, they too often fell prey to attitudes of narrow-minded rationalism and utilitarianism. The elder Tieck, however—a master ropemaker by trade—possessed a respectable collection of books to which his son had access, and in later years the author claimed to have acquired from his father's copy of Goethe's *Götz von Berlichingen* (1773) an enduring love of old Germany, of which his "progressive" father would not at all have approved. Wackenroder's father was of patrician stock, a jurist and top-ranking civil servant who rose to prominence as mayor of Berlin. He was opposed to any pursuits which might lead his son away from a useful life of public service and, in particiular, had to combat his love of music. Nevertheless, he saw to it that he received the best possible liberal education and provided him with musical instruction, including composition, from the best teachers available. One of his teachers was none other than Karl Friedrich Zelter, later Goethe's friend and main adviser in musical matters. With Tieck, Wackenroder was a frequent visitor too at the house of Johann Friedrich Reichardt, one of the principal figures in the German music world, and here he was able not only to hear chamber music and to discuss music and literature, but also, again with Tieck, to

engage in amateur theatricals. Even at this time, Wacken-
roder seems to have set his heart on a life devoted to the
arts and, upon completion of high school in 1792, he
resisted committing himself to the legal career which had
been plotted out for him, even going so far as to contem-
plate running off to Italy with Tieck. His father was ada-
mant, however, and insisted that he should prepare him-
self thoroughly for entering university as a student of law
by studying for a further year under a private tutor.

In 1792 Wackenroder and Tieck were separated for a
year; while Tieck went to Halle to study history, lan-
guages, and literature, Wackenroder commenced his pri-
vate studies. Happily, his tutor, Erduin Julius Koch,
possessed a love of the arts no less passionate than
Wackenroder's. Koch was more than an enthusiast, how-
ever; he was, in fact, an outstanding scholar and one of
the very few men in Germany at that time capable of
appreciating the importance and value of medieval Ger-
man literature. This appreciation he passed on to Wacken-
roder, and with it an understanding, which he shared with
and had derived from Herder, of the necessity of ap-
proaching every work of art as a product of the culture,
country, and age which produced it.

Wackenroder's growing enthusiasm for old German lit-
erature, which he conveyed in letters to an at-first skep-
tical Tieck, extended to envelop other art forms when the
two were re-united in 1793 and matriculated together at
the University of Erlangen in Franconia, southern Ger-
many. From Erlangen, Wackenroder and Tieck were able
to pay frequent visits to Nuremberg, which lay not far
distant. To these natives of modern Berlin, the city of

Nuremberg, so rich in buildings, monuments, and art-
works of the Middle Ages and Renaissance, bore testi-
mony to a great historical and artistic past of which they
had been scarcely aware and which—most important—
struck them as being essentially German in character.
They visited the churches of St. Sebaldus and St. Law-
rence, wandered entranced through the narrow winding
streets of the old town with its quaint medieval houses,
and climbed up to the castle with its legendary associa-
tions and its reminders of German imperial splendor. In
libraries they consulted works of old German literature,
including those of Hans Sachs, while in public and private
collections they inspected many works by Albrecht Dürer,
as well as other artists of the fifteenth and sixteenth cen-
turies, such as Peter Vischer and Adam Krafft.

Other, longer trips were taken through Franconia in
1793, and it would be difficult to exaggerate the importance
of these not only for Wackenroder and Tieck personally,
but for the development of the entire Romantic movement
in Germany. They saw the Baroque pilgrimage church of
Vierzehnheiligen and the monastery at Banz, and in Bam-
berg they not only visited the cathedral, the monastery-
church of St. Michael, the town hall, the bishop's palace,
and other buildings (structures dating from the late Ro-
manesque to the Baroque), but also witnessed High Mass
in the cathedral. They even participated in the solemn
ceremonial procession through the streets, and this, with
its colorful pageantry and ringing of bells, inspired them
with awe and made them the more receptive to the Mass
itself, which overwhelmed their senses in the majestic
cathedral. This exposure to the ambience of the Catholic
Baroque, with its paradoxical merging of the spiritual and

the sensuous, and its subservience of all art forms (music, architecture, painting, sculpture, and the drama of the Mass) to one overriding objective—the transmission of religious experience—was little short of a revelation to the two young men from Enlightened, Protestant Prussia. In the art gallery of the Baroque castle of Pommersfelden near Bamberg, Wackenroder and Tieck were also profoundly moved by a painting of the Madonna, then thought to be by Raphael. These experiences, coupled with their impressions of old German art in Nuremberg, convinced them of the dual importance of religious feeling and national inspiration for the creation of great art.

Though the Franconian sojourn was of central importance for the production of *Outpourings*, other influences, particularly upon Wackenroder, must also be considered.[2] In Berlin, Wackenroder had already been introduced to the appreciation of art by Karl Philipp Moritz. This strange and wayward genius, the main representative of the Goethe cult in Berlin, was known to Wackenroder personally from Reichardt's *soirées,* which they both frequented. Wackenroder also heard his lectures on art history at the Berlin Academy of Fine Arts, where Moritz was a professor. It is likely that on these occasions Moritz impressed upon the younger man his anti-rationalistic, emotional view of life and art. Certainly, verbal effusiveness and a passionate conviction that beauty in art may be *felt* but ultimately eludes comprehension are as signal features of *Outpourings* as of Moritz's writings.

Wackenroder's art studies, begun under Moritz, were continued under Johann Dominicus Fiorillo at the University of Göttingen, where Wackenroder and Tieck pursued their studies after only one semester in Erlangen.

Fiorillo dealt at length with the life and works of Dürer, and was at pains to stress the intimate alliance between art and religion in the Middle Ages, probably strengthening Wackenroder's conviction of the importance of religious sentiment for *all* art. Wackenroder was introduced by Fiorillo to the literature of art history and methods of art criticism and may be said to have received a firm grounding in these disciplines. Yet it is evident that in *Outpourings* he has proceeded not at all academically, as has been shown in detail by comparisons of Wackenroder's essays with his sources, the most important of which were the works of Vasari, Bellori, and Malvasia (in Italian), and of Sandrart, Mengs, and J. G. Bohm (in German).[3] What at all times determines Wackenroder's treatment is neither scholarly respect for his source materials nor a critical reappraisal of them, but his desire to illustrate through biographical sketches or characterizations of individual artworks his notion of the artist as an inspired being, and of art as a manifestation of the Divine. One would receive a very distorted impression of Dürer, for instance, if one were to rely on Wackenroder's portrayal of him as the naive, pious, homespun craftsman. Indeed, *Outpourings* is probably as much to blame for this "romantic" picture of Dürer which, despite ample evidence to the contrary, still persists in the public imagination, as it is to be commended for acknowledging the stature of this artist who was insufficiently admired or respected by Wackenroder's contemporaries. Like Dürer, Raphael too was as sophisticated and complex a man as he was an artist, so that Wackenroder's picture of him as merely childlike and otherworldly is as oversimplified as his characterization of Italy itself, which is conceived

as the homeland of Chrsitian art, without a single refer-
ence to the classical and pagan sources of Renaissance
painting, sculpture, and architecture. The essay "Raphael's
Vision" provides a good example of Wackenroder's proce-
dure. The anecdote related here has been invented by
Wackenroder to account for Raphael's words to the Count
of Castiglione: "Since one encounters so few beautiful
female figures, I cling to a certain image which dwells
within me." Significantly, however, Raphael's words in
actuality referred to a painting not of the Virgin Mary, but
of the pagan nymph Galatea. As A. Gillies has aptly put
it: "The whole book is at bottom a myth, framed around
real source-study."[4]

It is, of course, the work's religious component—both in
the intensity of its expression and the extent of its applica-
tion—which constituted its most revolutionary feature,
though this, too, was not wholly unprecedented. Johann
Georg Hamann (1730–88), one of the most seminal
minds of eighteenth-century Germany, and, following
him, Johann Gottfried Herder (1744–1803), had under-
stood nature to be an emanation of the Divine, and poetry
(particularly the poetry of primitive societies) to be the
expression of an intuitive awareness of being and of God.
Wackenroder shared their views on nature, and ascribed
to all art the properties which they attributed to poetry.
Nature "is like a fragmentary oracular utterance from
the mouth of the Divinity" (p. 62–3), while art "reveals to
us the treasures of the human breast, turns our gaze in-
ward, and shows us the Invisible, I mean all that is noble,
sublime, and divine in human form" (p. 62). Wackenroder
repeatedly emphasizes the imaginative quality in any
genuine artwork is a gift of God and, as such, must be

venerated both by practicing artists and by people capable only of enjoying art. His essentially mystical conception of art, which came to be universally accepted by Romantic writers, is of considerable sociological interest. In the course of the eighteenth century, rationalism and the philosophy of Enlightenment had undermined the position of the Church, and as a consequence the mystical (though not the social or the moral) function of orthodox religion was increasingly assumed by art, while artists were regarded—or, more often, regarded themselves—as "Brahmans," "a higher caste" of men (Friedrich Schlegel) because they alone were capable of persuading men of the reality and validity of higher truths through their extraordinary gifts. Though it is true that Wackenroder does not altogether disregard the extra-religious, mechanistic aspects of art (for example, in the essay on Leonardo da Vinci), he most certainly stresses Hamann's and Herder's view of artistic creation as an inspired activity. He proceeds beyond their standpoint, however, in couching his views in an emphatically Christian context and in underscoring the importance of the moral sense as a prerequisite for both the creation and the appreciation of artworks. When he portrays art as the pious maidservant of the Christian religion, he breaks not only with the neoclassical traditions of the art academies of the age, but also with Hamann and Herder, and becomes an initiator of the Christian art of the nineteenth century.

The all-pervading religiosity of *Outpourings* is given a peculiarly Catholic turn in "Letter from a Young German Painter in Rome to His Friend in Nuremberg." Tieck, whose contribution this was, was the most receptive of writers and of men, who throughout his life tended to

adopt and reflect the ideas of those around him—whether it was his high school teacher Rambach, or Friedrich Schlegel, or later his philosopher-friend K. W. F. Solger. Here Tieck has not only absorbed Wackenroder's views, but has overstated them in a quite irresponsible fashion. The letter from the young German painter in Rome implies that the spirit of religious art is essentially Catholic (and all art for the friar is, of course, ultimately religious), and hence that one must either become or already be a Catholic in order fully to appreciate art or to practice it successfully. At no point does Wackenroder indicate that he shared this radical viewpoint, and his approach to art has properly been called Pietistic rather than Catholic.[5] Nevertheless, as the work stands in its entirety, one cannot but see it as having contributed to that fervor for Roman Catholicism which became so widespread in Germany in the Romantic period and which resulted in so great a number of notable (and notorious) conversions or reversions to Catholicism—including Friedrich and Dorothea Schlegel, Clemens Brentano, Joseph Görres, Zacharias Werner, Adam Müller, and Friedrich Overbeck.

Piety, often with a veneer of Catholicism, also became a common ingredient of literary works, as well as of paintings by artists such as the Nazarenes and Caspar David Friedrich. The tendency was lent further impetus by *Fantasies on Art for Friends of Art* (1799)[6] and by Tieck's novel *Franz Sternbald's Wanderings* (1798), which might, indeed, be regarded as a sort of continuation of *Outpourings,* especially since the work was conceived by Tieck and Wackenroder together and only Wackenroder's early and tragic death, in 1798, prevented his collaboration. Certainly, the Catholicizing tendencies—as well as the

antiquarianism—of *Outpourings* and *Sternbald* were a
main reason for Goethe's rejection of the works and of the
"art-loving, friarizing, Sternbaldizing nonsense" to which
he claimed they gave rise.

Closely related to the spiritual and religious content of
Outpourings are the work's more specificaly esthetic
implications, particularly its accent on the effect to be
achieved through a fusion of the art forms. Friedrich
Schlegel was later to state, in his celebrated definition of
Romantic poetry in his journal *Athenäum* in 1798, that
Romantic poetry should merge the literary genres, since
transcendental experience (the communication of which,
like Wackenroder and Tieck, he believed to be the only
proper goal of literature and of all art) could neither be
adequately conveyed nor fully comprehended within the
strictures of one genre alone. Writers should therefore
avail themselves of the manifold possibilities inherent in
all genres, so that they might the more readily attain their
purpose. Now, it is a mark of the outstanding originality
of *Outpourings* that—two years before Friedrich Schlegel's
Athenäum—they not only in themselves afforded an exam-
ple of Romantic poetry, but even surpassed Schlegel in
their vision of a universal Romantic art form. Though
Outpourings is best termed a collection of "creative es-
says," it in fact defies efforts at generic categorization. The
work comprehends biographical sketches, fictionalized
autobiography (the life of Wackenroder/Berglinger), an-
ecdotes, essays in epistolary form, and essays in more con-
ventional expository form. It also departs frequently from
referential prose, flowing over into lyrical prose or, on
occasion, into verse. Each essay then has its appointed
place within the framework of the whole, and the overall

impression is as of a contrapuntal interweaving of two main subjects: the divinity of art and the sacred mission of the artist. "Descriptions of Two Paintings" is of particular interest in a discussion of generic and formal experimentation, for it not only exemplifies a progression from prose to verse, but transmits one art form (painting) in terms of another (literary expression).

As a whole, of course, *Outpourings* offers a sympathetic interpretation through literature of the separate art forms of music, painting, sculpture, and architecture. The common, essentially religious, function of these, and the emotional intensity generated by their subtle interplay, had been impressed upon Wackenroder and Tieck by their experience of South German Baroque art, and this experience provided the substance for the "Letter from a Young German Painter in Rome to His Friend in Nuremberg." The focus of this letter, the painter's religious conversion through art, merits closer attention. The young painter enters a church for basically superficial reasons: to observe his sweetheart at her devotions and, to a lesser degree only, to hear a Latin Mass sung. Yet the music and the preparatory ceremonies attune him spiritually for the reception of the insights which are about to be vouchsafed to him. Vocal and instrumental music swell and uplift his soul, so that when the supreme moment arrives and the priest exposes the host to the congregation (the *gesture* rather than the host itself is stressed) and the other men and women fall to their knees, the painter is powerless to resist the force which has been awakened within him by the combination of "drama" and music. His inspiration is heightened by the paintings and architecture of the church, and the climax of his artistic experience is

the penetration of a religious mystery, confirmed by his conversion. The fascination for combining art forms displayed here can be seen to occur again and again in later Romantic writings—even in such dissimilar authors as Joseph von Eichendorff and E. T. A. Hoffmann—and one may regard the Mass as described here as an anticipation of Richard Wagner's views on the *Gesamtkunstwerk*. In works such as *Tristan and Isolde* (1865), *The Ring of the Nibelung* (1853–74), and *Parsifal* (1882)—representing the culmination of Romantic striving after a universal art work—Wagner attempted to convey the most sublime thoughts and emotions through the artful synthesis of music, drama, poetry, and visual effects.

The universality of *Outpourings* is on the one hand extended by Wackenroder's relativism in matters of taste, and on the other limited by his conviction of the value of nationalism for art, which, paradoxically, evolved out of his relativism. Especially "A Few Words Concerning Universality, Tolerance, and Love of Humanity in Art"—the most Herderian of the essays—enunciates a relativistic standpoint. All truly inspired art is but a reflection of God, who cannot be fully known, however, and so is perceived differently in different ages by different races and different individuals. At the same time, this essay pleads for an understanding and recognition of Gothic art. Gothic art, which at that period was wrongly understood to be wholly German in origin, had been praised before, both by Herder and by Goethe. The young Goethe of the essay "Of German Architecture" (1772) may indeed be looked upon as one of the initiators of the Gothic revival, while an interest in old German national subjects is evident also in his own compositions, such as *Götz von Berlichingen*

(1773) and *Faust* (published 1808, but conceived in the early 1770's). As he grew older, however, Goethe abandoned his cultural nationalism in favor of the cultivation of universal human themes, the most fitting vehicle for which, both in literature and the fine arts, he deemed to be the classical art forms of ancient Greece. Of prime importance in *Outpourings* in this context is the portrayal of Dürer. Dürer is depicted as an essentially German man and artist, painting lovingly and realistically the people and scenes of everyday life which he observed about him. His age witnessed the last flowering of German art (not only in the pictorial arts, but in sculpture, architecture, and literature), and both German art and the independent German spirit which produced it had since then been undermined by the sterile imitation of foreign ways. Appearing as it did in a period of neo-classicism in the arts, the Dürer essay is important as a rehabilitation of Dürer and medieval German art. Yet it is also more than that, for by implication it calls for the establishment of a new national art (which would also include literature) and for a strengthening of the German national consciousness through resistance to foreign fashions. The creation of a national literature, which was also later advocated by the Schlegels, and realized by Tieck as well as by younger writers like Achim von Arnim, Brentano, and Friedrich von Fouqué, was, of course, a main achievement of German Romanticism. Wackenroder's implicit plea for a restoration of the German spirit (which, it must be underlined, was cultural and totally apolitical in inspiration) had still further-reaching implications. It may be regarded as an early expression of aspirations which, taking on a political and social coloring and gaining wide currency

during the Napoleonic period (especially the period 1806–15 in Germany), were to have reverberations reaching down into the present century.

One aspect of Wackenroder's piety which has generally received scant consideration is its extension in the direction of nature veneration. Nature, though not a major concern of *Outpourings,* has a central function in the essay "Of Two Wonderful Languages and Their Mysterious Power." The friar turns to nature here, it is true, in order to elucidate his conception of art, yet his views on nature are also significant in their own right. Nature is seen to be immeasurably vast, the material manifestation of the Infinite; and through an innate sympathy for nature, of which he is part, man may obtain intimations of mysteries and higher truths which he cannot grasp through the agency of logic or reason alone. This understanding of nature as an emanation of the Divine Essence, as a mystery to be fathomed only by feeling and the imagination, was to become one of the commonplaces of European Romanticism, as familiar to readers of Tieck, Eichendorff, and Hoffmann as to readers of Lamartine and Hugo, or Wordsworth and Shelley. Romantic feeling for nature was given a philosophical basis in the works of F. W. J. von Schelling and extended also into the realms of music (Beethoven's *Pastoral Symphony,* 1808, or Mendelssohn's *Hebrides,* 1832) and painting. It nowhere received more brilliant expression than in the landscapes of Caspar David Friedrich, of which his friend Carl Gustav Carus wrote that they provided the clearest illustration of the nature philosophy of Schelling. The parallel between *Outpourings* and the work of Friedrich, though not attributable to direct influence, is nevertheless noteworthy, since the essays are

usually associated with the Nazarene group—of which Friedrich was not a member—to the exclusion of all other German painters.

The piety, sentimentality, and naivety which characterize *Outpourings of an Art-Loving Friar* in the main, should not lead readers to overlook a darker side of the work which receives no adumbration in its title. The friar is intent throughout to emphasize the kinship of art and religion. "Art is of heavenly provenance." (p. 27) "The appreciation of sublime art works is akin to prayer." (p. 70) etc. He substantiates his assertions through reference to (freely adapted) art history, and by citing examples both positive (as are most) and negative. Negative examples for instance, are provided by Piero di Cosimo, and Francesco Francia who, only through his death, testifies to a new-found reverence for the sanctity of art. All but one of the friar's examples, however, including the fictitious German painter in Rome and the apprentice Antonio and his friend Jacobo, had lived in the past, when religion, art, and life had been intertwined in harmonious union. Only in his last essay does the friar turn to his own day, to tell the story of Joseph Berglinger. The musician Berglinger, who is in fact Wackenroder's literary projection of himself, had in his youth nurtured ambitions of reveling in uninterrupted fantasies and pouring forth the fullness of his heart in beautiful melodies. But he is condemned to live in unpoetic surroundings. His ethereal enthusiasm is held in check by prosaic responsibilities, either the justifiable claims of humanity (his father wanted him to relinquish music for medicine) or the unsavory obligation of having to compose music on command for an undiscerning public. Berglinger is an artist es-

tranged from society, and he gradually comes to accept that a musician may have to renounce all hope of influencing others, and create for himself alone. Torn between the demands of life and of art, Berglinger perishes in the conflict, just as his creator Wackenroder was to perish when, forced to study and to practice law against his deeper inclinations, he suffered a gradual deterioration of health and died "of a nervous fever" (doubtless of psychosomatic origin). Joseph Berglinger, the outsider, is the prototype of the modern Romantic artist, and one of the first of a host of Romantic and post-Romantic alienated artist figures from Tieck's Franz Sternbald to Hoffmann's Johannes Kriesler and Thomas Mann's Tonio Kröger. Berglinger's anguish is palliated to some extent by the charms of music. Yet it is this same music which, even as it transports him to sublime heights of inspiration, disables him for the business of living, revealing that destructive potential of music of which Schopenhauer, Nietzsche, and Thomas Mann were later to write so perceptively.

Outpourings was widely, if not universally, acclaimed on its appearance. August Wilhelm Schlegel praised the work highly in a review, though he also cautioned that its religious and national elements would be misinterpreted by readers incapable of appreciating its relativism. Among readers guilty of this shortcoming must be counted Goethe —even though the book's viewpoint so strongly resembled his own of earlier years that it was believed in certain quarters he was the anonymous author. Judging the book's emphasis on feeling, nationalism, and religion (which he interpreted as Catholicism) to be hostile to the furtherance of objective criticism on the one hand and the emergence of a universal human art on the other, Goethe com-

Goethe suspected author

bated its tendencies through his journal *Propyläen* (1798–1800) but his efforts to stimulate the creation of a neo-classical style here were in the long run fruitless, for it was *Outpourings,* not Goethe, that set the trend for the ensuing period.

The most direct influence exerted by *Outpourings* was in the area of painting and graphics, where its impact was intensified through the writings of Friedrich Schlegel. Though Schlegel had paid little heed to *Outpourings* on its appearance, he soon afterward developed a view of art analogous to—and indeed more radical than—that held by Wackenroder and Tieck. During a sojourn in Paris from 1802 to 1804, Schlegel had the opportunity to inspect some of the best collections of old Netherlandish, German, and Italian paintings then in existence. His understanding and appreciation of these were refined through his acquaintance with J. B. Bertram and the brothers Melchior and Sulpiz Boisserée, who were at that time collecting examples of old German and Netherlandish religious art which had become available through the secularization of monasteries subsequent to the territorial adjustments following the Peace of Lunéville (1801). The outcome was a series of descriptions of paintings in his journal *Europa* (1803–05). Here Schlegel asserts that the only purpose of art is to extol religion, and he calls upon German painters to treat Christian subjects and to derive their inspiration from primitive artists. The mature Raphael and later Italian artists are rejected as models, for they had contributed to a decay in art by seeking effect through false idealization. Recommended, however, are the younger Raphael and painters before him, though the primitive German artists are found to be especially worthy of emulation

because, according to Schlegel, they are both more realistic and more sincerely pious than the Italians. Now, *Outpourings,* though it had in fact dealt with the art of the High Renaissance in the main, had treated it as if it were primitive art.[7] The age of Michelangelo, for instance, is "the earliest period of Italian painting" (p. 78), and the native piety and childlike reverence and simplicity of the artists and their works are at all times accentuated. As a result, *Outpourings* may be said to have stimulated an interest in genuine early Italian art (Quattrocento and earlier) and in medieval art in general, the more so since the much-praised Dürer was an artist who belonged in part to the medieval tradition as well as to the modern period.

The prevailing approach to art, which the friar so despised for its pedantry and critical and mechanical emphasis, also aroused the dissatisfaction of six young students of art at the Academy in Vienna. In 1809, these artists—Friedrich Overbeck, Franz Pforr, Ludwig Vogel, Joseph Sutter, Joseph Wintergerst, and Johann Konrad Hottinger —formed an association, which they called the Brotherhood of St. Luke in honor of the patron saint of the medieval painters' guilds. Their aim was to restore German art to eminence through a new realism and through an emulation of the spirit of simplicity and piety which they admired in the works of Dürer and Raphael. To this end, they resolved to copy nature (not plaster models of classical sculptures, as was then the practice in art academies) and to imbue their works with feeling and moral consciousness. The leaders of the group, Overbeck and Pforr, were undoubtedly influenced by thier reading of *Outpourings.* In 1810 the group removed (without Sutter and

Wintergerst) to Rome, where they received permission to establish themselves in the vacated monastery of San Isidoro. Here each had his cell where he worked and slept and (though reveling was not entirely unknown) generally lived a life of devotion to art, of the sort of which the art-loving friar would have approved. An examination of paintings by the group,[8] who later became known as the Nazarenes (partly because of their piety, and partly because of their long hair parted in the middle "in the Nazarene manner"), reveals striking similarities to paintings of Raphael and the Quattrocento, and to old German art, particularly that of Dürer. Overbeck was the main practitioner of Italianate religious art, while Pforr was attracted to old German subjects. The group's ambition to achieve a harmonious synthesis of Italian and German elements is eloquently symbolized in Overbeck's painting *Italia and Germania* (1828), which portrays two maidens—the one dark, the other fair—embracing before a double landscape representing characteristic features of the Italian and German countrysides.

The Nazarenes rapidly became the most respected and popular of German painters, especially when they were joined in Rome by Peter Cornelius, Julius Schnorr von Carolsfeld, Carl Philipp Fohr, Wilhelm Schadow, and others. That the group was originally inspired by a work of literature, and that its members continued to show an interest in literature and in combining literature with the pictorial arts is suggested by many of their subjects. Cornelius designed marginal illustrations for Goethe's *Faust* in the Dürer style; Overbeck completed a series of Düreresque wood-engravings of biblical scenes; Schnorr von Carolsfeld painted frescos illustrating the *Nibelungen*

Saga in the Royal Palace in Munich. This latter undertaking exemplifies another Nazarene endeavor, originated by Cornelius: the revival of the technique of fresco painting, which had fallen into decay since the Renaissance. The Nazarenes' greatest successes as a group were scored by two quite typical undertakings: their decoration of the walls of the villa of J. S. Bartholdy, the Prussian Consul-General in Rome, on the subject of *Joseph in Egypt;* and their frescos for the villa of the Marchesa Carlo Massimo, portraying scenes from the works of Dante, Tasso, and Ariosto.

It was through the Nazarenes, too, that the message of *Outpourings* was carried beyond the borders of Germany to a wider European audience. Jean-Dominique Ingres, for instance, became familiar with the Nazarenes during his residence in Rome (1806–20), and it was probably they who stimulated that interest in the Quattrocento and in religious painting which left its mark on some of his own works, such as *Christ Giving the Keys to Peter* (1817).[9] Later, it was this side of Ingres' work which was developed by his pupil J. H. Flandrin and by Ary Scheffer, the two most "Nazarene" of French painters. Yet the main impact of the Nazarenes was felt not in France, but in Britain, where their works were popularized through prints and received official approval through the good offices of the Prince Consort, himself a German. The atmosphere, too, was particularly favorable for the reception of religious art owing to the activities of the Oxford Movement within the Church of England. Nazarene influence is to be seen in the works of the Pre-Raphaelites and their immediate predecessors. Two of the principal forerunners and (later) advocates of Pre-Raphaelitism, Ford Madox

Brown and William Dyce, spent some time in Rome and
were admirers of the Nazarenes, especially of Overbeck
and Cornelius. Religious, historical, and literary subjects—
all dear to the hearts of the Nazarenes—are also evident
in the paintings of these two British painters, for example,
in Brown's *Chaucer at the Court of Edward III* (1851)
and Dyce's *Jacob and Rachel* (1853). Brown became the
teacher of Dante Gabriel Rossetti, and Dyce frequently
employed as his assistant William Holman Hunt, which
two painters, together with John Everett Millais, formed
the nucleus of the Pre-Raphaelite Brotherhood (founded
in 1848), whose very name recalls the Brotherhood of
St. Luke. (Rossetti had wanted to call it the Early Chris-
tian Brotherhood.) Paintings by these three and by other
artists associated to a greater or lesser extent with Pre-
Raphaelitism—such as William Bell Scott, Walter Dev-
erell, Frederick Sandys, Noël Paton, and Edward Burne-
Jones—readily reveal affinities with Nazarene works.[10] The
Pre-Raphaelites and the Nazarenes (or those who were
still alive after 1848) accused each other of excessive de-
pendence on Italian models and adherence to Romantic
historical or legendary themes. The fact is, however, that
both groups were to a degree guilty of antiquarianism
and of Romantic escapism, and this, together with their
moral earnestness and the purity of their artistic concep-
tion, may well be what constitutes the charm of their
works today, long after their "revolutionary" impact has
passed. Both groups were, indeed, revolutionary in their
opposition to academic rule-mongering and to the belief
that a knowledge of technique is enough to produce great
artworks. Yet they were conservative in their goal, which
was the restoration of art through the qualities of simplic-

ity, sincerity, and devotion which they found in the eminent masters of the past. These are objectives which the art-loving friar would have applauded, as he would have nodded in agreement with Hunt—who had probably never heard of *Outpourings*—when he wrote in his memoirs:

> Michael Angelo said that carrying a box of colors did not make a painter, and in our day to flaunt trivial fancies into dainty form, cherished by idle patrons as the choicest examples of taste, cannot be consistent with the high service which art is called upon to render. . . . Art, as of old, should stamp a nation's individuality; it should be the witness of its life to all eternity. . . . The office of the artist should be looked upon as a priest's service in the temple of nature.[11]

Outpourings cannot be said to have influenced the production of music to any extent, though it did make an impression on one author of musical talent, and it is noteworthy that the merging of art forms which the work prefigures became a main concern of Romantic musicians. E. T. A. Hoffmann, though best known today as a writer of tales, was also a gifted painter and a musician and composer of stature. One of his principal literary creations, Johannes Kreisler, is an eccentric musician who suffers from that same conflict between art and life as wrought the destruction of Joseph Berglinger, on whom he is modeled. Hoffmann composed both chamber music and opera, his most notable contribution in the latter area being based on Fouqué's Romantic tale *Undine*. It seems particularly fitting that some of Hoffmann's own tales, together with episodes from his life, should have provided the sub-

ject for Offenbach's *Tales of Hoffmann* (1881), that
Tchaikovsky's *Nutcracker* ballet (1892) should have been
inspired by one of Hoffmann's stories, and that Schu-
mann's cycle of piano pieces *Kreisleriana* (1838) should
be named after Johannes Kreisler. Robert Schumann,
Jacques Offenbach, and Peter Ilyich Tchaikovsky are all
Romantic composers, and Romanticism in music derived—
musically, at any rate—largely from the experiments of
Beethoven. Essentially Romantic, for instance, is the union
of music and drama in *Fidelio* (1805) which departs from
the accepted operatic form of the day in that it is sung in
German (not Italian) and in its relative emphasis on the
dramatic (as distinguished from the musical) aspects of
opera through the elimination of recitative, and the intro-
duction of the spoken word.[12] Beethoven's *Pastoral Sym-
phony* (1808) also bears testimony to his Romantic lean-
ings, for in his program notes to this symphony he indi-
cates that the music is intended to be "more an expression
of feeling than painting," thus revealing both tone-paint-
ing and the transmission of feeling to have been his objec-
tives. The *Pastoral Symphony* may be regarded as the
point of departure for Romantic program music, which
sets itself the goal of painting a picture, or creating a
mood, or conveying an idea through sounds. Examples of
this, and at the same time of the interest taken by Roman-
tic musicians in literary subjects, are given by Mendel-
ssohn's *Midsummer Night's Dream* (1826), Berlioz' *Har-
old in Italy* (1834) and *Romeo and Juliet* (1839), and
Listz's *Hamlet* (1849), *Faust Symphony* (1854), and
Dante Symphony (1856). If Wagner's *Gesamtkunstwerk*
represents the fulfillment on a grand scale of Romantic
yearnings for artistic synthesis, then the Romantic *Lied* is

an analogous accomplishment scarcely less impressive for being on a more modest and intimate scale. What distinguishes the art songs of Schumann, Schubert, Brahms, Wolf, and others from earlier shorter vocal pieces is the way in which they merge poetry and music, giving both voice and accompanying instrument their full due, without emphasizing one to the detriment of the other. Often, too, a composer will not only convey the feeling or mood of a poem, but will seek to extend its reference by painting a picture in sound of an event or a scene, as does Schubert in *The Trout* (1820) or *The Erl-King* (1821), or Wolf in *Elf's Song* (1889). Verbal emblems of this Romantic striving after synthesis are the paradoxical labels of Mendelssohn's *Songs without Words* (1832–45) or Listz's "Symphonic Poems."

Outpourings of Art-Loving Friar may be said, then, to afford a wide range of Romantic views, indicating, anticipating, and at times stimulating developments in the literature, art, and music of the nineteenth century. That this wealth of ideas was enunciated at such an early date should evoke the reader's admiration and respect, while the book's engaging charm should invite him further to explore the almost infinite perspectives onto which it opens.

NOTES

1. See the English introduction to A. Gillies (ed.), *Herzensergiessungen eines kunstliebenden Klosterbruders: together with*

Wackenroder's contributions to the Phantasien über die Kunst für Freunde der Kunst (Oxford, 1948), pp. xxxv-xxxvi. Divergent opinions on authorship are also discussed briefly here.

2. See A. Gillies, "Wackenroder's Apprenticeship to Literature: his Teachers and their Influence," *German Studies presented to H. G. Fiedler* (Oxford, 1938), pp. 187-216.

3. See, for instance, E. Dessauer, *Wackenroders Herzensergiessungen in ihrem Verhältnis zu Vasari,* Studien zur vergleichenden Literaturgeschichte, VI (Berlin, 1907). There is no comparable study in English, though Gillies's "Note on the Sources" (*Herzensergießungen,* pp. 157-159) is useful.

4. Gillies, *Herzensergießungen,* p. xxxvi.

5. *Wilhelm Heinrich Wackenroder's "Confessions" and "Fantasies,"* tr. Mary Hurst Schubert (University Park, 1971), p. 29.

6. Essays by Wackenroder and Tieck not included in the *Outpourings.* Edited by Tieck.

7. W. D. Robson-Scott, "German Romantcism and the Visual Arts," in Siegbert Prawer (ed.) *The Romantic Period in Germany* (London, 1970), p. 261.

8. See the many reproductions in Konrad Kaiser (ed.) *Klassizismus und Romantik in Deutschland. Gemälde aus der Sammlung Georg Schäfer, Schweinfurt* (Obbach über Schweinfurt, 1966) and Keith Andrews, *The Nazarenes, A Brotherhood of German Painters in Rome* (Oxford, 1964). Andrews' distinguished book provides the best discussion of the Nazarenes available.

9. Andrews, pp. 73-74.

10. A representative selection of Pre-Raphaelite works can be found in Percy H. Bate, *The English Pre-Raphaelite Painters, Their Associates and Successors* (London, 1899), Robin Ironside, *Pre-Raphaelite Painters* (London, 1948), and Jeremy Maas, *Victorian Painters* (New York, 1969).

11. W. Holman Hunt, *Pre-Raphaelitism and the Pre-Raphaelite Brotherhood,* 2 vols. (London, 1905), pp. xiii, xv.

12. The Influence on Romantic opera of Mozart's *Magic Flute* (1791)—in German and with spoken dialogue—was also considerable.

Outpourings
of an
Art-Loving Friar

To the Reader of These Pages

Tieck

𝕿he following essays have taken shape over the years in the solitude of a cloister, from where my thoughts seldom stray to the world which I have left far behind. In my youth, love of art consumed me, and like a trusty friend this love has stood by me to my life's end. Scarcely aware of what I was doing and prompted only by an inner urging, I have written down these my recollected impressions, and I beg you, dear reader, to look upon them with indulgence. They are not written in the style of the present day, for I have no command over this style, nor, to be honest, have I any love for it.

In my youth I was deeply involved in affairs of the world. Art was my overriding passion, and I wished to devote to it my life and all my meager talents. In the estimation of some friends, I was not unskilled at drawing, and both my copies and my original compositions met with some approval. Yet the very mention of the sublime artist-saints of the past would cause me to tremble in awe and reverence. At the thought of Raphael or Michelangelo it seemed strange, even foolish, that I should presume to take brush or charcoal in my hand. I confess, indeed, that on occasion I would weep tears of inexpressible and profoundly felt melancholy when I recalled their lives and works. I was never capable—and the very idea would have seemed blasphemous to me—of distinguishing the good from the "bad" in my chosen favorites or of lining them up for review with a cold and critical eye as do some of our

3

young artists and self-styled art-lovers these days. So I will openly confess to have little fondness for the works of Herr von Ramdohr,† and whoever loves Ramdohr's writings may as well lay mine aside forthwith, for they will not please him. These pages, which were not originally meant for publication, are dedicated exclusively to aspiring young artists, or to youths who intend to devote themselves to art and still nourish in their pious, modest hearts awe and veneration for bygone days. They may perhaps be touched by my poor words and so be moved to still profounder reverence, for they will read with the same love as has inspired me to write.

Heaven has decreed that I should end my days in a cloister; so these efforts are all that I can now do for art. Should they be not ungraciously received, they may be followed by a second collection,‡ in which I will record my views on some individual art works, if God grant me health and opportunity to organize my notes on the subject and put them into coherent form.

†Friedrich Wilhelm Basilius von Ramdohr (1757–1822), German jurist, diplomat, and art critic, noted for his insistence on the observance of convention and rules in art. (Translator's note)

‡This second collection never appeared during Wackenroder's lifetime, but his essays destined for it found their way into *Fantasies on Art for Friends of Art* (1799), which also contained contributions by Tieck and was edited by Tieck. (Tr. note)

Raphael's Vision

The inspiration of poets and artists has ever been a major source of contention and dispute among men. The common man cannot understand its workings and has some absurdly false ideas on the matter. That is why the revelations of artists of genius, no less than the mysteries of our holy religion, are subjected to so much garbled and nonsensical commentary—and it makes no difference whether the commentators proceed systematically or unsystematically, methodically or unmethodically. The self-styled theorists and methodologists describe artistic inspiration from hearsay alone, and are quite content when with their vain and vulgar sophistry they have raked together enough empty words to paraphrase, however vaguely, a notion whose essence cannot be expressed in words and whose ultimate significance eludes them. They talk of artistic inspiration as if it were something they could lay their hands on. They interpret it and prattle on about it at great length, when by rights they should blush to utter such a sacred word, for they have no inkling as to what it means.

With what a torrent of vacuous words have our over-sophisticated modern writers sinned on the subject of the Ideal in the fine arts! They admit that the painter or sculptor arrives at his conceptions by extraordinary means, not through normal, everyday experience; they concede that this happens in a mysterious fashion; and yet they pretend to themselves and to their followers that they know how it comes about. I think they must be ashamed to admit

5

that there might be hidden or concealed in the human breast anything of which they, in their youthful presumption, might be ignorant. Others go even farther, and in their disbelief and blindness turn to mockery, scornfully denying any divine element in art enthusiasm and rejecting outright any special distinction or sanctity in even the rarest and most sublime of souls. I have no time for such scoffers, however, and it is not to them that I address myself.

Yet I do wish to teach a lesson to those sophists whom I mentioned above. They ruin the tender minds of their protégés by instilling in them impertinent and facile opinions on higher things as if they were things of this earth, so implanting in them the illusion that they might take by storm what the greatest artists have frankly acquired through nothing short of divine inspiration.

So many anecdotes have been written down and recounted; so many edifying sayings of artists have been recorded and cited, times without number. What surprises me is that people have listened to them with no more than superficial wonderment, without anyone suspecting the divinity of art to which they bear eloquent testimony or recognizing God's presence here as, indeed, in all of Nature.

I for my part have always believed in the divinity of art; but now a bright light has been cast on what I once sensed only dimly. I rejoice that Heaven has selected me to exalt its name by giving clearest proof of its unacknowledged mysteries: I have erected a new altar to the glory of God.

In a letter to the Count of Castiglione, Raphael, the brightest star in the heaven of art, has vouchsafed to us the following words, which are worth more than gold to

me and which I can never read without a tremor of awe and devotion:

"Since one encounters so few beautiful female figures, I cling to a certain image which dwells within me."*

Quite unexpectedly and to my boundless joy, I have recently come to understand the full meaning of these portentous words.

I was searching through the rich store of old manuscripts in our monastery, when among many a worthless dusty parchment I chanced upon some pages from the hand of Bramante, whose presence here I am at a loss to explain. On one of the sheets I found the following account, which I have translated and reproduce here without further ado:

"For my own pleasure and so that I may remember its details, I wish to record here a wondrous occurrence which befell my dear friend Raphael and which he confided to me under the seal of secrecy. Some time ago I was expressing my heartfelt admiration for his exquisite Madonnas and Holy Families and was begging and imploring him to tell me whom on earth he had used as a model for the incomparable beauty, the touching countenance, and the unsurpassed expressiveness of his Holy Virgins. After keeping me in suspense for a time with his usual childlike modesty and reticence, he became very agitated, threw his arms around my neck in tears, and revealed his secret to me. He told me how since his tenderest years he had felt an especial devotion to the Mother of God, so that the mere mention of her name was sometimes enough to make him feel quite melancholy. Later, when he turned to

* Essendo carestia di belle donne, io mi servo di certa idea che me viene al mente.

painting, it had always been his noblest ambition to paint the Virgin Mary in all her heavenly perfection. But he had long thought himself unequal to the task. Day and night, his mind was ever busy painting her, but he had been quite unable to complete the picture to his satisfaction. It was always as if his imagination were working in the dark. And yet at times it seemed as if a beam of light shone down from Heaven into his soul, so that he beheld her form in every detail just as he wished it. Yet the form slipped from his mind again, and he had never been able to retain it for more than an instant. So his soul had known constant disquiet. He never caught more than a fleeting glimpse of her features, and his shadowy impressions refused to merge into a clear picture. Yet in the end he had been unable to restrain himself and with trembling hand had begun a painting of the Holy Virgin; and as he worked, his soul became more and more enflamed. Once, in the night, after having prayed to the Virgin in his dreams as he often did, he had awakened with a start, sore oppressed. In the darkness his eye was drawn to a brightness on the wall opposite his couch, and when he looked more closely he perceived that his picture of the Madonna, which had been hanging unfinished on the wall, was now completed and had come to life in the warm radiance. The divine presence in this picture had so overwhelmed him that he had burst out in a flood of tears. The eyes had gazed at him with an expression infinitely touching, and it had seemed as if the figure might move at any moment; indeed he had the impression that it did in fact move. The greatest miracle of all was that it seemed that this was the picture which he had always wanted to paint, though he had never had more than a vague and confused

notion of it. He had no recollection of how he fell asleep again. Next morning he had awakened as if newborn. The vision was imprinted forever on his soul and his senses, and from then on he was able to portray the Mother of God as he had always envisioned her, and he had always felt a certain reverence for his own pictures.—That is what my dear friend Raphael told me, and this miracle has seemed so momentous and astounding to me that I have set it down for my own pleasure."

Such are the contents of the priceless pages which I chanced upon. Will people now understand what the divine Raphael meant by his remarkable words: "I cling to a certain image which dwells within me"? Will they, enlightened by this manifest revelation of heavenly omnipotence, now grasp the profound and noble significance of those simple words spoken from the depths of his innocent soul? Will they now finally come to see that all this profane gossip about artistic inspiration is downright blasphemous—and acknowledge that it is to be attributed to nothing short of the direct intermediation of God?

Yet I will say no more and leave everyone to his own thoughts, as befits a subject worthy of earnest contemplation.

Yearning for Italy

By some strange chance, I have remained in possession of the following jottings, which I wrote in my early youth when I was tormented by the desire of finally visiting Italy, the Promised Land of art.

Night and day my soul takes flight to those beauteous and joyous regions which figure in all my dreams and are calling me away. Will my desire, will my yearning forever be in vain? So many journey there and return without knowing where they have been or what they have seen, for no one loves that land and its native art as passionately as do I.

Why is it so distant that I cannot reach it in a few days on foot? that I might then fall to my knees before the immortal works of the great artists, confessing all my admiration and love? that their spirits might hear me and welcome me, their most faithful disciple?

If ever my friends unroll a map, I am moved almost to tears; for then I wander in spirit through cities, towns, and villages—to feel only too soon, alas! that I have imagined it all.

No worldly ambitions tempt me; but shall I never know the grace of living but once for divine art alone?

> Shall I languish here from longing
> And quite pine away with love?
> And will destiny ignore me,

Ever damn to unfulfillment
 All this striving and desire?
Am I, then, indeed forsaken,
 A companion of the damned?
Oh, how happy is the mortal
Who is predestined by the gods
 To devote his life to art!

Bliss continues to elude me.
 How long must this anguish last?
Yet though bitter doubts assail me,
Still the stars turn in their courses,
 And at last the day will come!

Then up and away!
After long slumbers,
 After deep rest,
 Through meadows and woods,
O'er flowering fields
 I'll leave for home!

Then fly to greet me
Garlanded angels,
 Bearing blessings,
 Radiant with bliss!
They lead me from travail
To sweetness and peace,
 To joy and composure
In the homeland of art!

The Remarkable Death of Francesco Francia, A Painter Renowned in His Time and the Founder of the Lombard School

Just as the age which saw the revival of science and learning produced scholars unsurpassed for their universality, humanity, and intellectual vigor, so too the age in which the art of painting rose like a phoenix from the ashes in which it had long lain inert was outstanding for the sublimity and nobility of its artists. That was the truly heroic age of art, and (like Ossian) one might well sigh that the vitality and grandeur of that heroic period have now vanished from the earth. Many artists arose in many places and achieved eminence through their own powers alone. Their lives and works were momentous and were worthy of being recorded for posterity in lengthy chronicles, of the sort which still come down to us today from the pens of art enthusiasts of the period. Their inner lives were as deserving of our veneration as are their bearded countenances, which still command our respect when we see them in the precious collections of their portraits. Their lives were marked by extraordinary happenings, occurrences which now seem incredible to many because enthusiasm, which these days glimmers in only a few rare breasts like a feeble little lamp, enflamed all men in that golden age. After-generations, in their degeneracy, cast doubt or heap ridicule on many an authenticated story from those days, because the divine spark of enthusiasm has been extinguished in their souls.

One of the most remarkable stories of this kind, and one whihc I have never been able to read without astonishment, though my heart has never been tempted to doubt its veracity, concerns the death of the ancient painter Francesco Francia, who was the originator and founder of the school which was formed in Bologna and Lombardy.

This Francesco was the son of a humble tradesman, but through his unflagging energy and boundless zeal he had scaled the topmost pinnacle of fame. In his youth he was first apprenticed to a goldsmith, and he sculpted such artful objects in gold and silver that everyone who saw them was astonished. For years too he engraved the dies for every medallion stamped in Lombardy, and all the princes and dukes of the province considered it an honor to have their likenesses engraved on their coins by his hand. Those were still the days when all the nobles and all the commoners of a country could inspire pride in their artist-compatriots with their never-ending, jubilant applause. Countless numbers of princely personages passed through Bologna and hastened to have Francesco draw their likenesses, then engrave them and stamp them in metal.

But Francesco's dynamic and fiery spirit was searching after a new field of endeavor, and the more his burning ambitions were fulfilled the more impatient he became to open up for himself a totally new and still untrodden path to fame. When he was already forty years of age, he took up the challenge of a new art form. With infinite patience he trained his hand in the use of the paintbrush, and concentrated all his thoughts on the study of large-scale composition and the effect of color. It was astounding how quickly he succeeded in producing works which amazed

all Bologna. He was indeed an excellent painter, for though he had several rivals, and even though the divine Raphael was then working in Rome, his works always deserved to be considered among the most distinguished. Beauty in art, to be sure, is not such a poor or meager thing that it can become the prerogative of one single individual, nor is the crown of beauty a prize which falls by good fortune to one chosen artist alone; rather does its light split up into a thousand rays, whose glories are deflected into our enraptured eyes in countless ways by the great artists whom Heaven has sent down to us.

Now, it was Francesco's destiny to belong to the first generation of noble Italian artists, who enjoyed a respect which was the greater and more universal for their having built an entirely new and brilliant empire of art on the ruins of barbarism. And in Lombardy it was Francesco himself who was the founder, and first prince as it were, of this newly established realm. His skillful hand completed countless numbers of magnificent paintings which found their way not only into every corner of Lombardy (no town of which wished it to be said to its disgrace that it did not possess at least one example of his work), but into every other region of Italy; and everyone who had the good fortune to see them broadcast his fame far and wide. Italian princes and dukes vied with each other to possess pictures by him, and compliments poured in upon him from all sides. Travellers carried his name with them everywhere they went, and echoes of their eulogies returned to flatter his ear. When visiting Rome, citizens of Bologna would commend their local artist to Raphael, and he, who had also seen and admired some of his works, assured him in letters of his respect and affection with his

characteristic graciousness and amiability. Contemporary authors could not refrain from weaving laudatory references to him into all their works, directing the eyes of posterity to him and solemnly relating how he was worshipped like a god. One of them° was even bold enough to write that, after seeing Francesco's madonnas, Raphael abandoned the stiffness which he still retained from the school of Perugia and assumed a grander style.

What effect could these repeated assaults on his modesty have on our spirited Francesco other than to swell his soul with the noblest pride in his artistry and implant in him a belief in a divine genius dwelling in his breast. Where does one encounter this exalted pride these days? One will look in vain for it among the artists of our day, who are proud of *themselves* to be sure, but not proud of their *art*.

Raphael was the only living painter whom Francesco would acknowledge even to approach him in stature. He had, however, never had the good fortune to see a picture by him, for he had never gone far from Bologna during his lifetime. Nevertheless, from the many descriptions which he had heard, he had formed a definite picture in his mind of Raphael's manner, and because of this and particularly because of the modest and affable tone of Raphael's letters he was firmly convinced that he was his equal in most of his works and perhaps even surpassed him in some. It was not until he was very old that he saw one of Raphael's pictures with his own eyes.

Quite unexpectedly, he received a letter from Raphael informing him that he had just completed an altar paint-

°Cavazzone

ing of St. Cecilia which was destined for the church of
St. John in Bologna, adding that he would send the work
to him, Francesco, as his friend, and begging him to be
so kind as to have it properly installed in its place. In the
same spirit, he also requested Francesco to improve or
correct any part of the picture which might have been
damaged in transport or which he deemed deficient or
inaccurate in itself. Francesco was in raptures to receive
this letter, in which Raphael humbly gave him leave to
alter his picture as he pleased, and he could hardly wait
for the painting to arrive. He did not know what was in
store for him!

One day, when he was returning home from an outing,
his pupils hurried out to meet him and told him joyfully
that Raphael's picture had arrived during his absence and
that they had already set it up in his room in the most
effective light. Beside himself with excitement, Francesco
dashed into his house.

But how can I convey to the present-day world the feel-
ings which the excellent Francesco felt rend his heart at
the sight of this picture? He felt as the man must feel who,
in a transport of delight, is about to embrace the brother
from whom he has been separated since childhood, only
suddenly to see an angel of light before him. His soul was
transpierced. He felt as if he were sinking to his knees
before a higher being, overwhelmed with heartfelt
remorse.

He stood there thunderstruck. And his pupils, not know-
ing what to think, crowded around the old man, support-
ing him and asking him what had happened.

Once he had recovered somewhat, he could not take his
eyes from the picture, which, in its divine beauty, sur-

passed anything that he had ever seen. How suddenly he had fallen from his great height! How bitterly he had to atone for the sin of having all too arrogantly reached for the stars and having been so inordinate in his ambition as to have placed himself above the unsurpassable Raphael! He tore his gray hair and wept tears of bitter grief that he had wasted his life in vain and arduous striving (only making himself more foolish in the process), and that now in the end, near death, his eyes had been opened so that he must look back upon his whole past life as a bungled work, lamentable and fragmentary. Like St. Cecilia, he raised his eyes to Heaven, exposing his bleeding and remorseful heart and begging humbly for forgiveness.

He felt so weak that his pupils had to help him to bed. As he was leaving the room, his eyes fell upon some of his paintings and were drawn especially to his own St. Cecilia on the Point of Death, which was still hanging there, and he almost expired with sorrow.

From that time onward his mind was in a state of constant confusion, and people nearly always noticed a certain absent-mindedness about him. The debility of old age, and the exhaustion of a mind which had for so long been strenuously active creating so many thousands of figures also contributed to shaking the foundation of the house of his soul. All the infinitely varied forms which from the beginning had occupied his painter's mind and had become reality in the colors and lines of his canvas now flashed distorted through his soul and were the demons which came to frighten him in his bouts of fever. Before his pupils knew what was happening, they found him dead in bed.

And so this man first achieved undisputed greatness

through the awareness of his own insignificance in comparison to the heavenly Raphael. The good genius of art, moreover, has long since pronounced him a saint in the eyes of the initiated and has crowned his head with the halo which becomes him as a true martyr of art enthusiasm.

This account of the death of Francesco Francia has been handed down to us by old Vasari, in whom the spirit of the ancient artists still dwelt. Those critical individuals who neither will nor can believe in genius any more than in miracles of the supernatural, and who would like to resolve the whole world into prose, mock the fantastic tales of this venerable old chronicler of the artists and insolently assert that Francesco Francia died of poisoning.

Raphael and the Apprentice

In those days when an admiring world still counted Raphael among the living—Raphael, whose name I cannot easily utter without instinctively calling him "the divine" —in those days—ah! how gladly I would forgo all the wit and wisdom of later centuries to have been alive then!—in those days there lived in a little town in the vicinity of Florence a young man whom we will call Antonio and who liked to try his hand in the art of painting. From his childhood, he had felt a compelling urge to paint, and even as a boy he would eagerly copy any holy picture which fell into his hands. Yet despite his untiring zeal and

his iron resolve to create some work of outstanding value, he possessed a certain narrow-mindedness and timidity of spirit, which always cause the flower of art to grow stunted and frail, inhibiting it from ever shooting up to heaven straight and strong: an unfortunate constellation of endowments which has already produced more than one half-artist.

Antonio had already tried his hand in the manner of various masters of the period, and with such success that even he was extraordinarily pleased with the accuracy of his copies, and was able quite objectively to assess the progress which he had made over the years. Finally he saw some drawings and paintings by Raphael. He had often heard his name mentioned in tones of the highest commendation and so he lost no time in setting about copying works by such a celebrated artist. However, when he found himself quite unable to complete his copies satisfactorily and could not guess the reason for it, he laid his brush impatiently aside and, after reflecting on what he might do, finally composed the following letter:

To the most esteemed painter,
Raphael of Urbino.
Forgive me for not knowing how I should address you, for you are a man whose excellence surpasses all my comprehension, and I have, moreover, had little practice in writing. I have long pondered over whether it would be at all proper for me to write without ever having met you personally, but since everyone speaks of your sociable and friendly disposition I have finally been so bold as to set pen to paper.

Yet I will not waste your valuable time with many words, for I can imagine how industrious you must be, and I will open up my heart to you immediately and lay my request before you with every urgency.

I am a young painter, a novice in this estimable art which I love above all else and which fills my heart with such joy that I can scarcely imagine anyone— excepting of course yourself and other famous artists of our day—having a more ardent love or consuming passion for art than I have. I spare no effort to come ever a little closer to my goal which I see in the distance before me. Not one day—indeed, I might say not one hour—am I idle, and not a day passes but I notice some little progress which I have made. Now, I have already practiced diligently in the manner of many of the famous painters of our age, but when I began to copy your works it was as if I had learnt nothing at all and had to start again from the beginning. I have already painted onto my panels so many heads in which no mistake or fault can be found either in outline or in light and shade. Yet when I look at the heads of your apostles and disciples or of your Madonnas with the infant Jesus, and transfer them stroke for stroke onto my panel with such meticulous care that my eyes smart from the strain, and then step back and survey my work in its entirety, comparing it with the original, I am shocked that the two are such worlds apart and that my faces are quite different from yours. And yet when one first examines your heads, they seem almost easier than other painters', for they look so extremely natural, as if one immediately recognized the people they are meant to

represent or as if one had already met them in real life. Nor do I find in your works such difficult or drastic foreshortening of limbs as many other modern painters employ in order to display their mastery of artistic technique, usually making life difficult for us poor apprentices.

That is why—deeply though I have pondered the matter—I am at a total loss to explain what is special about your pictures, and am quite unable to discover why one cannot imitate you properly or ever quite equal you. I implore and beseech you to lend me your support and to tell me (for you must know best) what I must do to become even a little like you. How firmly I will impress your words upon my memory! How eagerly I will follow them! Sometimes—forgive me!—I have had the suspicion that in your work you must possess some secret of which no one else can form any conception. I would give anything to watch you at work for even half a day, but perhaps you do not admit observers. Or if I were a great lord I would offer you thousands upon thousands of gold pieces in return for your secret.

I beg you to be indulgent with me for imposing upon you with so much empty chatter. You are a most outstanding man and must look down upon all other human beings with contempt.

You must work night and day to produce such exquisite works, and in your youth you surely made more progress in one day than I would in a year. Well, in the future I too will push my abilities to their very limits.

Others, more perceptive than I, award special

praise to the expressiveness of your pictures and maintain that no one excells you in depicting almost palpably the state of mind of your figures, so that one might almost guess their thoughts from their bearing and gestures alone. But of these things I have little understanding as yet.

I must finally stop imposing upon you, however. Ah! what relief and solace it would bring if you were to send even a few words of advice to

<div style="text-align: right">Your ardent admirer
Antonio.</div>

So ran Antonio's letter to Raphael; and with a smile, Raphael answered as follows:

My dear Antonio,

It is good that you nourish such a great love for art in your breast and that you apply yourself so diligently to your work, and it has given me great pleasure to hear it from you. Unfortunately, however, I cannot tell you what you wish to know—not because it is a secret which I would not betray (for I would most gladly share it with you or with anyone else), but because I myself do not know it.

I can see your unwillingness to believe me, and yet it is so. I can no more tell you why my hands fashion pictures in one way and not in another than any man can account for having a harsh or a soft voice.

People find much that is special in my paintings, and when they draw my attention to this or that admirable quality in them I am myself often amused

at how successful my work has been; for I produce pictures as if in a pleasant dream, and while at work I always concentrate more on what I am depicting than on how I should depict it.

If you cannot properly understand and imitate what you find most characteristic in my works, then my advice, my dear Antonio, is that you should select as your model one of the other justly famous masters of the present day, for each and every one has some feature worthy of imitation. I myself have benefitted from copying them, and my eye indeed still derives inspiration from their many and varied qualities. Yet that I paint in this one peculiar way now and in no other seems to be an inborn aptitude—just as every painter seems to have his own way of painting. I have not acquired it by the sweat of my brow, nor can one set about acquiring such a thing through conscious study. In the meantime, continue to practice art with love, and farewell.

A Letter from the Young Florentine Painter Antonio to His Friend Jacobo in Rome

Beloved Brother,

Do not be surprised that I have not written for so long, for diverse activities have made time pass unbelievably fast for me. But now I will write to you more often, for I wish to share with you, my dearest

friend, all my thoughts and feelings. You know how it
was once my constant complaint that I was a worth-
less and discreditable apprentice in the noble art of
painting. Well, now my soul has received a wonder-
ful and mysterious impulse, so that I can breathe
more freely and fearlessly and need no longer stand
in such humility and abasement before the paintings
of the great masters.

How am I now to describe to you how and through
what agency this has come about? What a poor crea-
ture man is, my dear Jacobo, for even when he car-
ries a priceless jewel in his bosom he must conceal it
like a miser and can neither show it to his friend nor
share it with him. Then our only language is tears,
sighs, or a touch of the hand. That is the situation in
which I now find myself, and that is why I would
like to have you here now to take your dear hand and
place it on my throbbing heart. I do not know
whether others have felt like this before me—whether
others have been granted the favor of finding through
love such a beautiful way to the adoration of art. For
if one word could express my present feelings, this
word must be Love. It is Love which now rules my
heart and my mind.

I feel as if a curtain had been drawn away from
before my eyes and I could now see for the first time
what men have always called nature and the beauty
of this earth. Mountains and clouds, the heavens and
the sunset, all of these have changed for me and have
been brought down closer to me. With what love and
inexpressible longing would I now embrace Raphael,
who dwells among the angels because he was too

good and too sublime for us and this earth! Burning
tears of exaltation and of the purest devotion now
blind my earthly eye and flood my spirit with divine
intoxication when I stand before his works and im-
press them deeply upon my mind and heart. I can
truthfully say that until now I had no notion of what
distinguishes art from all of man's other worldly
activities and occupations. I have become purer and
better, and so only now have gained admittance to
the sacred mysteries of our art. How I now adore the
Mother of God and the august apostles in those in-
spired pictures which formerly I wished only to copy
stroke for stroke with clumsy brush and unfeeling eye!
Now tears come to my eyes, my hand trembles, and
my innermost heart is shaken so that I apply the colors
to the canvas almost unconsciously as it were, yet with
such success that I am afterwards satisfied. Oh, if only
Raphael were still alive that I might see him, speak
to him, and tell him my feelings! He must have
known Amalia, for I find her and I find my whole heart
again in his works. All his Madonnas resemble my
beloved Amalia.

Now, too, I experience moments of noble and bold
inventiveness. I have already begun a few original
works, and often when I arise from a meal or have
just been engaged in some trivial conversation I am
myself astonished at the audacity of my undertakings.
My guiding spirit spurs me on again, however, so that
in spite of everything I do not lose courage.

I am as different from myself in my former state as
the tightly closed bud of the gorgeous lily is from the
great silvery star which gazes at the sun from atop its

dark stem. There is much that I still wish to accomplish with unfailing vigor.

When I am sleeping, Amalia's name is suspended over me, shielding me like a golden canopy. Often I awake because I hear her name spoken in sweet tones, as if one of Raphael's cherubs were calling me in its mocking, caressing voice. Then the opening in the canopy gradually closes again with rippling harmonies, and blissful dreams descend upon my eyes on light wings.

Ah, Jacobo, believe me when I say that I have never been more your friend than I am now, but do not mock

Your happy Antonio.

JACOBO'S ANSWER

Your welcome letter, my dearest Antonio, was most moving and cheering. I do not need to wish you happiness, for now you are truly happy, and far be it from me to mock you, for then I would not deserve the grace of Heaven, which has selected me as an artist to be the instrument of its glory.

I understand very well your drive to work and your ever-active inventiveness. You deserve my praise, indeed my envy. Yet you will not take it amiss if I add a few words to what you have said. The fact that I am so much older than you both in years and in experience perhaps gives me the right to talk.

I am not altogether happy with what you write about art. You are not the first to have taken this path which you are now following, but I believe that the

truly great artist must proceed beyond the point which you have reached. It is true that love opens our eyes to ourselves and to the world, so that the soul becomes more composed and more devout, and a thousand dormant sentiments burst forth with brilliant fire from every hidden recess of the heart. Then one learns to understand religion and the wonders of Heaven, the spirit becomes more humble and yet more proud, and art especially speaks to our innermost heart in all its varied tones. Yet now the artist is all too easily exposed to the danger of seeking himself in every work of art. All his sentiments will wander off uncontrolled in one direction only, and so he will sacrifice his many-sided talent to one single feeling. Guard against this, my dear Antonio, for in the end it can lead to the most restricting and superficial mannerism. The artist must find in himself a response to every work of beauty, but he must not strain to seek himself in it. Art must come before love in his heart, for art is of heavenly provenance. Only religion may be dearer to him. Art must become a sacred love or a loved religion, if I may express myself in such terms. Earthly love may then take its place after art. Then a divine and refreshing breeze will carry every sentiment and every beautiful flower into this newly conquered land, which is bathed in the light of dawn and echoes with the sounds of heavenly joy.

Do not misconstrue my words, my dearest, dearest Antonio. It is my reverence for art which speaks through me, and I know that you will interpret everything for the best. Farewell.

The Model of an Inventive Yet Erudite Painter, As Exemplified By Leonardo da Vinci, the Renowned Founder of the Florentine School

The age in which the art of painting was resurrected in Italy produced men to whom the modern world ought properly to look up as if to saints in their glory. One might almost say of them that it was they who first tamed and, as it were, enchanted wild nature with their magic arts— or that it was they who first struck the spark of art from the chaos of creation. Each one of them shone forth in the splendor of his own considerable perfection, and there are altars erected to many of them in the temple of art.

On this occasion I have selected from among these the celebrated founder of the Florentine School, the never sufficiently praised Leonardo da Vinci, in order to present him for the benefit of those interested as the model of a truly learned and profoundly scholarly artist and the epitome of a tireless and yet imaginative worker. Let our disciples of art in their eagerness for knowledge learn from his example that it is not enough to swear allegiance to a flag, or merely to train the hand to be pliable in managing the brush or, armed with a feigned enthusiasm both frivolous and superficial, to inveigh against profound study when it is aimed at uncovering the basic foundations of art. Such an example will teach them that the genius of art associates willingly enough with the stern Minerva, and that a great and generous soul, even when concentrated upon one main activity, reflects the entire and varied picture of human science in perfect harmony and beauty.

The man of whom we are speaking saw the light of day in the village of Vinci, which lies in the valley of the Arno not far from the splendid city of Florence. The skill and intelligence with which nature had endowed him already manifested themselves in his tender youth, as often happens with such chosen spirits, and could clearly be seen peeping out from behind the bright-colored figures which his childish hand produced with the greatest of ease. This is like the first bubblings of a merry little brook which later becomes a mighty and awesome river. Whoever knows it will not halt the water in its course—for then it will burst walls and dykes—but will let it have its way. Leonardo's father did just that by letting the boy follow his inborn inclinations, and by apprenticing him to the renowned and meritorious Andrea Verocchio in Florence.

Alas! who today knows or can still name the men who in those days shone like brilliant stars in the heavens? Like stars, too, they have set, and nothing more is heard of them. One cannot even be sure that they ever existed. Nor was this Andrea Verocchio one of the least significant of them. He was devoted to the Holy Trinity of the fine arts— to painting, sculpture, and architecture—for in those days it was nothing unusual for one man's spirit to have room enough for such a three-fold love and ability. Besides that, he was knowledgeable in mathematics and was also an enthusiast of music. It may well be that his example, which early impressed itself upon Leonardo's receptive soul, had a profound influence on him, though the seeds of his greatness must already have been sown deep in his heart. Yet who, in any case, can trace all the fine strands of cause and effect in the history of the development of

another human soul, since the individual himself during his lifetime is not always aware of the connection?

Before one can master any of the fine arts, even for the purpose of portraying solemn or melancholy subjects, one must possess a lively and alert mind; for slow and laborious effort is necessary to produce a perfect work for the delight of all the senses, and gloomy or incommunicative spirits have no inclination or desire, no courage or stamina to produce anything. The young Leonardo da Vinci possessed such an alert mind, and he eagerly practiced not only drawing and painting, but also sculpture, while for his recreation he played the violin and sang pretty songs. Wherever his enterprising spirit turned he was lightly borne up by the Muses and Graces as their favorite, and even in his leisure hours he never touched the vulgar ground of everyday existence. Of all occupations, however, painting was dearest to his heart, and to his teacher's shame he soon managed to surpass him: proof that art cannot actually be learnt or taught, but that its stream, if only directed and tended for a short distance, will gush forth exuberantly at its source.

His imagination was so fertile and prolific in every kind of meaningful and eloquent image that even in the turbulent years of his youth, when all his powers were forcing themselves violently to the surface, his temperament did not manifest itself in commonplace, insipid imitations, but in extraordinary, complex, one might almost say extravagant and fantastic, conceptions. For example, he once painted our first ancestors in a Paradise which he so richly adorned with every conceivable sort of wonderful and strangely-shaped animal and with such a painstakingly wrought profusion of different plants and trees that

observers were utterly amazed at the diversity, and simply could not take their eyes from the picture. Still more wonderful was the Medusa's head which he once painted on a wooden panel for a farmer. He composed this head by combining the features of every imaginable monstrosity and loathsome horror, so that one could not wish to see anything more terrifying. Experience and age later created order amidst this wild luxuriance of spirit.

Yet I will hasten to my main purpose, and see whether I can convey an impression of the versatility and dedication of this man.

In painting, he strove with zeal and perseverance after ever greater perfection, and not in one branch of painting alone, but in all branches. With his investigation of the mysteries of the brush he combined the keenest observation, which, like a guardian angel, accompanied him on all his ways through life, enabling him to reap the richest harvests for his favorite art, even where others were aware of nothing. And so he himself provided the best illustration of the lessons which he taught in his admirable work on painting: namely, that a painter should make himself universal and portray all things with respect for their special peculiarities, and not merely in accordance with one particular technique which he happens to have mastered; and further, that a painter should not become inseparably attached to one master alone, but should freely investigate nature in all its aspects, striving always to merit the name of grandson, not son of nature.

From this work—the only one of his scholarly writings to be published, and a work deserving to be called the Golden Book of Leonardo—it is evident how thoughtfully he always integrated his knowledge of the rules and me-

chanics of art with their practice. He was such a master of the human anatomy in every conceivable position and attitude, even the most subtle, that one might have thought that he had invented it himself. The first task which he always set himself was immediately to determine the precise physical and spiritual meaning which every figure was supposed to embody; for, as he himself makes clear in his book, every work of art must properly speak a double language, one of the body and one of the soul. At certain points in his book he indicates how a battle, a storm at sea, or a great crowd of people are to be painted, and in these passages his imagination is so bold and powerful that with a few words he sketches in the clearest and most eloquent features to form a remarkable whole.

Leonardo knew that the genius of the painter is intrinsically quite different from the enthusiasm of poets. It is not the painter's purpose to create something wholly out of his own mind; rather should his artistic sense range sedulously around outside him, enfolding all forms of creation with ease and agility and preserving their imprint and impression in the treasury of his spirit, so that when he sets his hand to his work the artist may find existent in him a complete world of things. Leonardo never went out walking without his sketchbook, for his eager eye found offerings for his Muse everywhere. One can truly say that a man is inflamed and transfused by the artistic sense when he subjects everything around him to his main occupation in this way. Leonardo would seize upon any little part of the human body which pleased him in any passerby, or any fleeting posture or attitude which he found charming, and would add these to his collection. He was

especially fond of people with odd faces and unusual hairstyles or beards, and when he encountered such people he would often follow them for long distances until he had imprinted them firmly on his senses, painting them later at home as lifelike as if they had sat for him in person. Similarly, when two people, believing themselves unobserved, would speak together quite freely and uninhibitedly, or when a violent argument took place, or when he encountered any other human passions or emotions raging unrestrained, he never failed to note the outlines of the scene and how the various parts fitted together to form a whole. Though it may seem ridiculous to many, he would often spend hours totally absorbed in some strange scratchings in colored stones or studying old decaying walls over which the hand of time had scattered all sorts of wonderful shapes and colors. If he contemplated these steadily, they would inspire in him many a clever idea for landscapes or battle scenes or strange attitudes and faces. That is why in his book he urges painters to seek pleasure in intense contemplation of such things, because orderless compositions of this sort stimulate the mind to inventions. One can see from this how the extraordinary and unsurpassed spirit of Leonardo was able to derive gold from all things, even from the basest and least significant.

In the *science* of painting, perhaps no artist has ever been more experienced or knowledgeable than he. A knowledge of the inner parts of the human body, and of how the whole system of cogs and levers operates in this machine; a knowledge of light and color, and of how these two act upon each other and reinforce each other; the science of perspective, in compliance with which objects at a distance appear smaller and fainter: all these sci-

ences, which constitute the very basis and foundation of art, he had absorbed and assimilated.

As has already been mentioned, however, Leonardo was not merely a great painter, but also a good sculptor and a respectable architect. He was learned in all branches of the mathematical sciences, a great connoisseur of music, a pleasant singer and violinist, and a talented poet. In short, if he had been alive in the age of heroes he would surely have been taken for a son of Apollo. He even took pleasure in distinguishing himself in skills which lay quite outside his province. He was, for instance, so proficient in riding and horsemanship as well as in fencing that, unless one knew better, one might easily have thought that he had devoted his whole life to these. He was so familiar with mechanical devices and with the mysterious forces inherent in natural bodies that, for a festive occasion, he once constructed a wooden model of a lion which was able to move by itself. On another occasion he made little birds from some light material, and these were able to soar up into the air quite freely on their own. He was, then, endowed with a natural fascination for always devising something new, and this kept him constantly active and striving. All his talents, however, were heightened by distinguished and charming manners, as jewels are highlighted in a gold setting. And so that even the most vulgar and stupid eye might be struck and impressed by this extraordinary man, Nature in her generosity had expressly endowed him with wonderful physical strength and, to culminate everything, with the noblest bearing and a face which one could not but love and respect.

The questing spirit of the earnest scientist seems so different in kind from the creative spirit of the artist that at

first glance one might almost think them two distinct spe-
cies of men. It is a fact that few mortals are so endowed
that they can worship at this twofold shrine. The man,
however, who finds in his own soul a sanctuary for all
those insights and powers normally shared among many,
and whose spirit with equal measure of zeal and good
fortune can calculate certainties by the process of reason-
ing and produce visual representations of his inner visions
by the labor of his hand—such a man must command the
astonishment and admiration of the whole world. And
when, in addition to this, he is devoted not to one art
alone, but unites many in himself, feels their mysterious
interrelationship, and senses in his soul the divine flame
dwelling in all of them, then truly this man has been won-
drously distinguished before all other men by the hand of
Heaven, and many will be unable to approach him even
in their thoughts.

The court of Lodovico Sforza, Duke of Milan, was the
principal stage on which Leonardo da Vinci, as director of
the Academy, unfolded his manifold talents. Here he dis-
played himself in exquisite paintings and sculptures, and
here he broadcast his good taste in the construction of
buildings. He was officially employed as a violinist among
the ranks of the musicians, yet with acute perspicuity he
also directed the difficult construction of an aqueduct
crossing mountains and valleys. He may be said almost to
have represented a complete academy of all human
knowledge and skills in his person alone. Before he under-
took the construction of the aqueduct, he withdrew to
Valverola, the country seat of one of his distinguished
friends, and there, favored by the rural Muse, he applied
himself with great industry to the mathematics of archi-

tecture. He later spent several years in this quiet country house, immersing himself in thoughtful speculation while applying his philosophical mind to the study of mathematics or of any other discipline likely to contribute to a basic theory of the fine arts. He also bore the stamp of his inward-turned wisdom in his exterior, for he let his hair and beard grow so long that he looked like a hermit. It was his unfailing industry, too, which some people would like to see as the motive for his never having married. During this sojourn in rural seclusion he first refined and purified the results of his studies with his intellect, tempering them with his own perceptive thoughts and observations, and then compiled them into lengthy books, which, written by his own dear hand, can still be seen in the great Ambrosian Library in Milan.

But alas! these, like so many other ancient, venerable, and dusty manuscripts in the libraries of the mighty, are untouched relics which the incomprehending sons of our age pass by, at most with an empty attestation of reverence. The manuscript is still waiting for the man who will awaken the spirit of the old painter sleeping his magic sleep there and release him from the bonds which have long constrained him.

To detail all the excellent beauties in Leonardo's many paintings would exceed the abilities of my pen. His most famous picture is probably his portrayal of the Last Supper in the refectory of the Dominicans in Milan. People admire in it the soulful expression on the faces of Jesus' disciples, as each one seems to ask Him: "Lord, is it I?" Those men of old who collected anecdotes about the artists relate how Leonardo, after completing the other figures, had hesitated a little, reconsidering and reflecting, or

(what is perhaps more accurate) waiting for a stroke of inspiration as to how he might best portray Judas' traitor face and the sublime countenance of Jesus. This circumstance caused the prior of the monastery to give manifest proof of his lack of understanding by taking him to task over his hesitation as if he were a day-laborer.

I must mention just one more painting of Leonardo's on account of a remarkable circumstance attendant upon its composition. I mean the portrait of Lisa del Giocondo (the wife of Francesco), on which he managed to work for four years without stifling the spirit and vitality of the whole by the most meticulous and careful working out of every detail. Each time this noble lady sat for him he would call in some musicians to cheer her with pleasant and joyful singing to the accompaniment of instruments. This was an extremely clever idea, for which I have always admired him. He knew only too well that people sitting for portraits often assume a dryness and earnest vacancy of expression which creates an unpleasing or even sinister impression when permanently fixed in the features of a painting. At the same time, however, he knew the effect of joyful music, how it is reflected in a face, softening all its features and transfusing them with charm, life, and mobility. In this way, he transferred the eloquent charm of her face undiminished onto his panel and in practicing painting made such effective use of music that the one cast its luster upon the other.

One can imagine how many talented painters Leonardo's school produced and how universally honored and respected he was in his own lifetime. Once, when he had completed no more than a preliminary sketch for a large altar panel in a monastery outside Florence, the reputa-

tion of this sketch was so considerable that for two days a crowd of townspeople pilgrimaged out to see it, and one would have thought that a festival or a procession was in progress.

Leonardo had settled in Florence again after Duke Lodovico Sforza of Milan had suffered complete defeat in the wars then ravaging Italy and the Milanese Academy had been totally disbanded. Then, in advanced old age, he was invited to France by King Francis I. This monarch esteemed Leonardo above all men and received him, then in his seventy-fifth year, with especial warmth and respect. He was not destined to spend long in this new country, however. The arduous journey and the different way of life must have precipitated the illness which befell him shortly after his arrival. The king showed great concern on his account and visited him assiduously in his illness. On one such occasion, when the king had come to visit, the old man tried to sit up in bed as he approached and to thank him for his graciousness, but was suddenly overcome by faintness. The king supported him in his arms, but his breath failed, and that mighty spirit which had accomplished so much that is great and which still stands today in all its perfection—that mighty spirit passed away, like a leaf swept from the face of the earth by a single gust of wind.

If, as some people think, the luster shed by diadems is a light particularly conducive to a flourishing of the arts, then one may to some extent regard the scene at the end of Leonardo's life as his apotheosis as an artist. At least in the eyes of the world, to expire in the arms of a king must have appeared a fitting reward for all his great deeds.

One may now perhaps ask whether it is my wish to set up Leonardo da Vinci, whom I have praised here so highly, as the foremost and most superlative of all paint-ers and to urge every aspiring artist to strive to become just like him. Instead of answering, however, I will ask in return whether it might not be permitted for once inten-tionally to restrict our gaze to one single individual of great and imposing spirit, in order to survey his peculiar merits adequately on their own terms and in the context of his life. And who, I may ask, could be so impudent as to weigh and measure artists' accomplishments in order to rank the artists according to merit with the arrogant rigor-ism of a judge, as moralists presume to pronounce the rela-tive worth of the virtuous and the vicious in accordance with strict precepts?

I am of the opinion that one can admire two spirits of a very dissimilar nature, as long as both possess great quali-ties. The spirits of men are just as infinitely varied as their faces; and do we not call a venerable, wrinkled, and wise old face just as beautiful as the enchanting, innocent, and tenderly sensitive face of the virgin? Yet at this compari-son someone might object that when the magic word Beauty rings out surely it is the second image, that of Venus Urania, which involuntarily and intuitively springs to mind. To this, I must admit, I have no answer.

The reader who, like me, is reminded by my two-fold image of the man whom I have just discussed and of the man whom I usually call "the divine," will perhaps find food for thought in this analogy. Suchlike fancies, when they come to our minds, often cast a wondrous light on ob-jects, illuminating them more brightly than the logical processes of reason. Beside the so-called higher powers of

perception there is, perhaps, a magic mirror in our souls which may sometimes show us things in their most vivid form.

Descriptions of Two Paintings

To my mind, a beautiful picture or painting ultimately eludes description, for as soon as we say more than one word about it our imaginations take leave of the canvas and weave a new illusion of reality out of nothingness. That is why the old chroniclers of art have always appeared very wise to me in calling paintings merely excellent, incomparable, or superb, for it seems to me impossible to say more than simply that about them. It has occurred to me, however, to attempt to describe some pictures in the manner exemplified by the following two poems, which came spontaneously to my mind and which I present here for their own sake and for public consideration, though I would not wish to overrate the value of this kind of writing.

FIRST PICTURE

The Holy Virgin with the Christ-Child and the boy John

Mary

Why am I so overjoyful, why
Was I chosen for this greatest blessing

Which a mortal woman ever knew?
All this excess of good fortune numbs me
And I cannot show my gratitude,
Not with tears and not with songs of joy.
Only smiles tinged with wistful sadness
Can I shower upon the Son of God,
For I hesitate to raise my eyes
And look upon our Heavenly Father.

Never will my happy eyes grow tired
Looking at this infant in my lap.
Ah! and yet what strange and solemn events,
Unsuspected by the guiltless child,
Proclaim their coming in these wise, blue eyes,
Even in his little, childish games.
How can I express what fills my breast?
Even now I feel as if I were in Heaven
When the thought illuminates my soul:
I, I am the mother of this child.

The Infant Jesus

Pretty and gay is the world all around me!
And yet I do not feel as other children:
Cannot lose myself in play,
Cannot feel the worth of worldly things,
Or sing out loud with unreflecting joy.
All earthly things which move
With bright activity before my eyes
Are for me a passing shadow-play,
Agreeable illusions.
But inwardly I exult,
Perceiving more splendid immaterial beauties
Which cannot be expressed.

The Boy John

Ah! how I adore the infant Jesus!
Ah! how sweetly and full of innocence
He sports in his mother's arms!
Dearest God in Heaven, hear my secret prayer!
Receive my thanks
And hear my praise for Your great grace.
I beg You, send Your blessings down upon me!

SECOND PICTURE

The Adoration of the Three Wise Men from the East

The Three Wise Men

Following the beams of that fair star, .
We three wise men from a distant land,
From the distant Orient have come,
Where the sun arises in its splendor.
Many years we strove to find the source
And the sum of knowledge and of wisdom,
And the Lord of All Things in His mercy
Granted crown and scepter to reward us,
And for all our strenuous mental efforts
Blessed our heads with white and silvery hair.
Yet we come now from the land of morning,
And we lay before You, wondrous child,
All the wisdom of our many years,
All our science and our precious knowledge.
Dressed resplendent in our regal robes,
Here we bow our humble heads before You,
And as worthy offerings and emblems

Of our veneration and devotion
Bring You gold and myrrh and frankincense.

Mary

Ah! praise the Lord, my soul!
Praise Him that He has sent me this glory
And exalted me in the eyes of the world!
For I have borne this little child
Who plays upon my lap,
Whom these wise men have come to worship
From their distant eastern home.
Ah! my eyes cannot bear the splendor,
Nor my heart the joy!
All the deepest wisdom of their years
They lay before the infant in the dust.
They bend their knees,
They bow their heads,
They spread their royal robes upon the ground.
Gold and frankincense and myrrh
Are offered as a sacrifice:
What a grand and solemn offering for the child!
Oh! how great the bliss that fills my mother's heart!
Yet strength fails me when I try to thank
These wise men for their grace and favor,
Or to raise my eyes in gratitude to Heaven.
But grand and splendid images
Dwell deep within my soul.

The Infant Jesus

Beauteous must be the land
Where the bright sun has its rising,
For how splendid are these men!

Why are they so old and gorgeous?
Ah! that is the sign of wisdom,
That their hair is silvery white
And their royal robes are golden.
And behold! what wondrous objects
They have brought to me as gifts!
Yet they kneel before me humbly.
Strange and wondrous men are these,
And I do not rightly know
What I properly should call them.

A Few Words Concerning Universality, Tolerance, and Love of Humanity in Art

The Almighty, who made our earth and all things in it, embraced all of creation with His gaze and poured down the stream of His blessings upon the whole earth. But from His mysterious workshop He scattered a thousand varied seeds of things over our globe which bear infinitely varied fruit and shoot up into the most immense and colorful gardens in His honor. In wondrous manner He guides His sun in measured circles around the terrestrial sphere, so that its rays reach the earth from a thousand different directions, extracting the marrow of the earth and shaping it into multiform creations in every clime.

With dispassionate eye He rests for one sublime moment upon the work of His hands and accepts with equal pleasure tribute from all of creation, both animate and

inanimate. The roaring of the lion is as pleasing to Him as the crying of the reindeer; and to Him the aloe smells as sweet as rose or hyacinth.

Man, too, proceeded from the hand of the Creator in a thousand forms. Brothers of the same family fail to recognize or to comprehend each other; they speak different languages and stare at each other in wonderment. Yet He knows them all and rejoices in them all. With dispassionate eye He rests upon the work of His hands and receives tribute from all of creation.

He hears the voices of men talk confusedly and in many different ways of divine things, and He knows that all of them—all, even without their knowledge or against their wishes—refer to Him, the Ineffable.

So, too, He hears men's innermost sensibilities talk different languages in different zones at different times, and He hears them quarrel and fail to reach an understanding. Yet for the Eternal Spirit, everything resolves into harmony; He knows that each man speaks the language which He created for him, that each man expresses his personal feelings as only he can and must. Though they quarrel in their blindness, He knows and recognizes that each one is right after his own fashion. He looks down upon each and every . one of them with pleasure and rejoices in the confusion of colors.

Art deserves to be called the flower of human sensibility. In the various zones of the earth it shoots up to Heaven in ever-changing forms, and from this crop too only one sweet fragrance rises to the Father of All, who holds the earth and all things in it in His hand.

In every work of art, in every zone of the earth, He sees the trace of that divine spark which, issuing from Him,

passed through the souls of men and into their little crea-
tions, which reflect it back to the great Creator again. The
Gothic temple is as pleasing to Him as the temple of the
Greeks; and the barbarous war songs of savages is to His
ear a music as sweet as elaborate chorales and anthems.

And when I now return to earth from Him, the Infinite,
passing through the immeasurable vastness of the heavens,
and when I look around among my fellow men and broth-
ers—alas! I must raise loud cries of lamentation that they
make such little effort to model themselves on their great
and eternal Father in Heaven. They are embroiled in dis-
putes and misunderstandings, and because each one
stands immovable on his own spot, incapable of surveying
the whole, they fail to see that they are all hastening
toward the same goal.

Stupid men cannot understand how there are antipodes
on our earth and how they themselves are antipodes. They
always imagine that where they are standing is the center
of everything—and their spirit lacks the wings with which
they might fly round the globe and enfold with one gaze
the whole earth, which is founded in itself.

Likewise, they regard their own feelings as the measure
of all beauty in art and pronounce decisive judgments on
everything as if from a judge's seat, without considering
that no one appointed them to be judges or that those
whom they condemn might just as easily set themselves
up as judges.

Why do you not condemn the Indians for speaking
Indian and not our language?

And yet you would condemn the Middle Ages for not
building the same kind of temples as the Greeks built?

Oh! use your intuition to find a way into other souls,

and recognize that you have received your spiritual gifts from the same hand as your misunderstood brothers! Strive to understand that every creature can create images from within himself only by means of the faculties which he has received from Heaven, and that all creations must conform to their makers. And if you cannot feel your way into all other beings and sense their works through a sympathy with their souls, then at least try to reach this understanding indirectly through the logic of reason.

If the disseminating hand of Heaven had let the seed of your soul fall upon the African desert, then you would have preached to everyone that glossy black skin, a flat round face, and short crinkled hair were essential constituents of the highest beauty, and you would have mocked or hated the first white men that you saw. If your soul had taken root and flowered a few hundred miles farther east in the soil of India, then you would have felt the mysterious spirit which, concealed from our senses, breathes in their little, strangely-shaped, many-armed idols, and if you saw the statue of the Medici Venus you would not know what to think of it. And if it had pleased Him in whose power you were and still are to cast you among the tribes of the South Sea islanders, you would find in every wild drumbeat and in their barbaric, strident, and rhythmic music a profound significance of which you understand nothing in your present state. But would you, in any of these cases, have received the gift of creativity or the gift of appreciating art from any source other than that eternal and universal source to which even now you owe thanks for all that is precious to you?

The basic logic of reason follows the same laws among all nations of the earth, though in one place it might be

applied to an infinitely vast range and in another place to a very restricted range of objects. Similarly, feeling for art in all its manifestations is but one and the same ray of heavenly light, which, however, breaks down into a thousand different colors by passing through the prism of sensibility, which is variously cut in various zones.

Beauty: a strange and mysterious word! First invent new words for every individual artistic experience, for every individual artwork! In each one a different color shimmers, and for each one different nerves are created in the human body.

Yet out of this one word Beauty you evolve a strict system by means of the art of reasoning and would force all men to feel in accordance with your rules and regulations —though you yourselves are bereft of feeling.

Whoever believes in a system has banished universal love from his heart! Intolerance of feeling is preferable to intolerance of reason; superstition is better than belief in systems.

Can you force the melancholy man to find pleasure in comic songs and merry dances? Or the sanguine man gladly to open his heart to the terrors of tragedy?

Oh! let every mortal creature and every people under the sun have their own beliefs and their own kind of happiness. Rejoice when others rejoice—even though you cannot rejoice at what is nearest and dearest to them.

The privilege has been vouchsafed to us, as sons of this century, of standing on the summit of a lofty mountain and beholding clearly with our own eyes many lands and ages laid out around us at our feet. Let us then avail ourselves of this good fortune and let our gaze range serenely over all ages and peoples. And let us strive to sense what

is *human* in all their varied sensibilities and works of sensibility.

Every being strives after an ideal of beauty, but it cannot escape its own self and sees ideal beauty only in itself. Just as each mortal eye receives its own impression of the rainbow, a different impression of beauty is reflected into every eye from the world around it. Universal, primordial beauty, however, which we can only *name* in moments of transfigured intuition but cannot resolve into words, reveals itself only to Him who made both the rainbow and the eye which beholds it.

I spoke of Him in the beginning and I return to Him once more, just as the spirit of art, just as every spirit proceeds from Him and rises to Him again as smoke from a sacrifice through the atmosphere of the earth.

In Pious Memory of Our Revered Forebear Albrecht Dürer, By an Art-Loving Friar

Nuremberg! You once famous city! How I loved to wander through your winding streets! With what childlike devotion did I behold your old German houses and churches, which so clearly bear the stamp of our national art! How deeply I love the works of that past time, those works which speak such a sturdy, powerful, and truthful language! How they take me back to those far-off days when you, Nuremberg, were the vigorous center of German art, and when within your walls there lived and

thrived an artistic spirit, both creative and dynamic; when
Master Hans Sachs, Adam Kraft the sculptor, and above
all Albrecht Dürer with his friend Wilibaldus Pirckheimer
and so many other honored and worthy men were still
alive! How often I have wished myself back to those
days! How often they have come to life again in my mind's
eye as I sat in your venerable libraries, Nuremberg, in a
confined corner in the dusk by the little round-paned win-
dows, poring over the folios of the worthy Hans Sachs or
over some other ancient, faded, worm-eaten document—
or as I walked beneath the bold vaults of your dark and
gloomy churches, where daylight filters in through
stained-glass windows to bathe all the statuary and paint-
ings of the past in wondrous light!

Again you look at me surprised, you of narrow mind
and little faith! Oh, yes! I have seen the myrtle groves of
Italy—and I know too that divine fire which dwells in the
hearts of mortals in the joyous south! Why must you call
me away to the land of my heart's desire, to where I have
spent the happiest hours of my life?—You who see boun-
daries everywhere, where none exist! Are Rome and Ger-
many not on *one* earth? Has our Heavenly Father not
built roads from north to south, and from east to west to
encompass the whole earth? Is one human life too short
for all of this? Can the Alps not be crossed?—If not, then
more than *one* kind of love must dwell in the human
breast.

Yet now my grieving spirit can only visit the hallowed
spot outside your walls, Nuremberg: the graveyard where
lie the bones of Albrecht Dürer, once the pride of Ger-
many, and indeed of Europe. They lie here, visited by
only a few, amidst countless gravestones, each of which is

decorated with a metal carving in the old German style and among which flourish tall sunflowers, making of this cemetery a delightful garden. So lie the forgotten bones of our dear Albrecht Dürer, for whose sake I am glad to be a German.

Heaven seems to have endowed few men so richly as it has me with the ability to comprehend the essence of your pictures and appreciate so warmly their uniqueness and peculiarity; for when I look around me I see few who linger before your grave with the same passionate love and veneration as do I.

Is it not as if the figures in your pictures were real people, talking together? Each one is so much himself that one would recognize him in a crowd; and each is so true to nature that he fulfills his purpose totally. No one is present in body alone, as is so often the case in the dainty pictures of modern artists; everyone is shown in the round, vitally alive. The mourner mourns; the prayer prays; the tyrant rages. Every figure speaks its own language, loudly and clearly. No arm moves needlessly, merely to delight the eye or for considerations of space. Every limb, every feature speaks to us forcefully, so that the spirit and the import of the whole is firmly impressed on our minds. Everything that the artist portrays we accept as true and it is imprinted indelibly on our memories.

How is it that our modern artists contrast so unfavorably with those admirable men of old, and especially with you, my beloved Dürer? How is it that all of you appear so much more earnest, weighty, and reverent in your approach to painting than these simpering artists of the present? In my imagination, I can see you, standing reflectively before the painting which you have begun—I can

see the notion to which you wish to give visible form hovering clearly before your eyes—I can see you pondering over which expressions and which poses might be depended upon to arouse the beholder most forcefully and stir him most intensely. I can see you then, with passionate involvement and an earnest smile, slowly and carefully painting onto the panel those beings so compatible with your living imagination. Our modern painters, by way of contrast, do not seem to want us to become seriously involved in what they show us. They work for genteel patrons who do not wish to be moved or ennobled by art, but seek in it a maximum of superficial brilliance and shallow diversion. They exert themselves to produce works which are models of charming and artful coloration; they test their wits in the distribution of light and shade; but the human figures in their paintings often seem to be present merely for the sake of the color and the light, a necessary evil as it were.

What a lamentable age we live in, that art—one of the most solemn and sublime of pursuits—has been reduced to a frivolous titillation of the senses! Have we lost our respect for man that we neglect him in art, considering showy colors and every sort of artificial lighting effect to be worthier of our attention?

In the writings of Martin Luther I once came across a remarkable passage on the importance of art which now springs to my mind. (I will not deny that, out of curiosity, I have occasionally looked into the writings of this man whose ardent supporter Albrecht was, and that I have found not a little truth concealed in them.) Luther asserts quite boldly and explicitly at one point that, after theology, music is foremost among all the arts and sciences

devised by man. I must openly confess that with this auda-
cious pronouncement the excellent Luther has quite won
my respect; for the soul which could utter such words
must have felt for art that profound veneration which—I
know not why—so few hearts possess and yet which, to my
mind, is so natural and important.

Now if the arts—that is, the most significant among
them, the creative arts—are really so important, it is a
mark of the utmost baseness and frivolity to reject Dürer's
expressive and edifying figures simply because they are
not endowed with that suave surface beauty which is
today considered the sole criterion of art. It betrays an
unwholesome and impure mind when a person closes his
ears to an apposite and penetrating sermon just because it
is not elegantly turned or because it is delivered in an
uncouth, unfamiliar accent or accompanied by clumsy
gestures. Spiritual content, however, does not prevent me
from recognizing and duly admiring external or merely
physical beauty wherever I encounter it in art.

It is also deemed a serious offense, my dear Dürer, that
you place your figures side by side naturally and comfort-
ably, without liking them together artfully to form an
organized group. I love this unadorned simplicity in you
and instinctively absorb first the soul and deeper signifi-
cance of your figures, without any such criticism occurring
to me. Yet many people seem to be so possessed by the
desire to criticize that one would think an evil demon
were driving them to despise and deride before allowing
them to observe calmly—and preventing them above all
from transcending the limitations of the present day
through an appreciation of the past. I readily concede to
our zealots of modernity that a young art student these

days can speak more cleverly and knowledgeably about color, light, and the grouping of figures than our old Dürer could. But is it the youth himself who speaks? Is it not rather the accumulated wisdom and experience of generations of artists speaking through him? The essence of art can be comprehended immediately by only a chosen few, whose mastery of technique, however, may be far from perfect; all the externals of art, on the other hand, are gradually developed toward perfection through invention, practice, and reflection. It is a piece of despicable and lamentable vanity to usurp for our own undeserving heads the crown of merit which belongs by right to past generations and to conceal our own nonentity behind borrowed plumes. Let our young luminaries take their hands from the old master of Nuremberg! And let no one presume to judge or mock him, who in his ignorance can still sneer that Dürer did not have Titian or Correggio as his teachers, or that people in those days wore quaint, old-fashioned clothes! For another reason why modern teachers refuse to acknowledge the beauty and nobility in his paintings, and in those of many another competent artist of that century, is because all their historical personages and even their Biblical figures are dressed in the costume of the artists' time. I, however, am of the opinion that every painter who is inspired by the personalities of past centuries must breath into them the spirit of his own day; and I find it natural and proper that the creative genius, in his love for all things strange and remote—including heavenly beings—, should make them more approachable by decking them out in the familiar and well-loved forms of his own age and his own surroundings.

When Albrecht painted, the Germans still possessed a

unique and firm national character and they played a dis-
tinguished role on the European stage. His paintings, too,
clearly and faithfully reflect this earnest, honest, and
sturdy character, not only in their externals and in the
faces of their subjects, but in their very spirit. In our day
this distinctive German character and, with it, German art
have disappeared. Young Germans learn the languages of
all the peoples of Europe, and they are required judi-
ciously to adjust their native way of thinking by drawing
on the spirit of all nations. The student of art is introduced
to Raphael's expressiveness, to the colors of the Venetian
school, the realism of the Netherlanders, and the magical
lighting effects of Correggio—and by imitating all of these
at once he is supposed to achieve the highest perfection.
Oh, what pathetic sophistry! Oh, how blind we are to be-
lieve that by combining every type of beauty and by
studying and plagiarizing the manifold great gifts of the
world's outstanding artists we can assimilate their spirit
and surpass them all in excellence! The days of our own
strength are past; we wish to stimulate our failing talents
by pitiful imitation and clever combination, and the out-
come is cold, sterile works, totally lacking in character.
German art was once a pious youth, reared at home
among relatives and within the walls of a little town. Now
that it has grown older it has become a polished man of
the world who in ridding himself of his provincialism has
sacrificed his feeling, his individuality, his very soul.

On no account would I have wished the enchanting Cor-
reggio, the magnificent Paolo Veronese, or the mighty
Michelangelo to have painted as Raphael did. Nor do I
agree with those who maintain: "Had Albrecht Dürer
only lived in Rome for a time and learnt from Raphael

what real beauty is and what 'the Ideal' means in art, he
would have become a great painter. As it is, one can only
pity him and wonder how he managed as well as he did."
I find nothing to regret in Dürer, and I thank Providence
that in him it gave to Germany a genuine national painter.
He would not have been true to himself, for his blood was
not Italian blood. He was not born for the idealism or the
noble sublimity of a Raphael. He derived pleasure from
showing us men as they really lived around him, and he
succeeded in this with distinction.

And yet, when in my youth I first saw paintings by
Raphael hanging in the same splendid gallery as paintings
by you, my beloved Dürer, I was amazed how among all
other artists whom I knew, these two had a particularly
close affinity to my heart. What I liked so much in both
was their way of portraying men in soul as well as in body,
so clearly and distinctly; so simply and directly, without
any of the ornamental superfluities of other painters. But
at that time I did not yet dare to reveal my opinion to
others, for I believed that everyone would laugh at me,
and I knew that most people perceive only a great deal of
clumsiness and pedantry in the old German painter. Nev-
ertheless, on the day on which I had visited that gallery
I was so occupied with this new thought that I fell asleep
with it on my mind and had in the night a delightful
vision which confirmed me in my belief. I dreamt that
after midnight I left the chamber of the castle in which I
was sleeping and, lighting my way with a torch, passed all
alone through the dark halls of the castle, arriving finally
at the picture gallery. When I came to the door I heard
an indistinct murmuring within; I opened—and gave a
sudden start, for every corner of the vast hall was illumi-

nated by an eerie light, and before several paintings there stood in person the imposing figures of their creators, wearing the old costumes in which I had seen them in pictures. One whom I recognized told me that they often came down from Heaven to earth, to linger in the still of night in this or that gallery and inspect the still-loved works of their hands. I recognized many Italian painters, but very few Netherlanders were to be seen. Reverently I passed among them—and then, oh wonder! there before my very eyes, standing hand in hand apart from all the others, were Raphael and Albrecht Dürer, looking calmly and in amicable silence at their paintings hanging together. I did not have the courage to address the divine Raphael; awe and a secret dread sealed my lips. I was just about to greet Albrecht, however, and pour forth my love for him—when there was a crash, everything faded, and I awoke in violent agitation.

Enraptured as I was by this vision, I was transported to even greater heights when soon afterward I read in the writings of old Vasari how during their lifetimes these two sublime painters, though they never met, had become friends through their works, and how Raphael had admired the honest, truthful works of the old German and had not thought them unworthy of his love.

Yet I must confess that from this time onward whenever I beheld works by these two painters I felt as I did in my dream. Though I would often attempt to explain to someone the very real merits of Albrecht's paintings and would even dare to enlarge upon their qualities, Raphael's works always so overwhelmed me and overawed me with their heavenly beauty that I was speechless and unable to explain clearly to anyone what I found so divine in them.

But now I will turn my attention exclusively to you, my dear Albrecht. Comparison is a serious impediment to any appreciation, and even the most sublime beauty in art makes its full and proper impact on us only when our gaze is not distracted by other beauties. Heaven has so distributed its gifts among the great artists of the world that we must pause before each one and pay to each his fair share of our respect.

Genuine art may flourish not only under Italian skies or under majestic domes and Corinthian columns—but under pointed arches, fantastically ornamented buildings, and Gothic spires.

Peace be with your bones, my dear Albrecht Dürer! And may you come to know how I love you and how in these latter days which you have never known I have become the herald of your fame. Blessed be your golden age, Nuremberg!—the only age when Germany could boast its own national art. Yet ages of splendor pass away from the earth and vanish like sun-drenched clouds passing over the vault of heaven. They fade and are forgotten; they live on in the hearts of only a few, called to life by their passionate love, by dusty books, or timeless works of art.

Nature = emanation of Divine Essence

Of Two Wonderful Languages and
Their Mysterious Power

The language of words is a precious gift of Heaven, and it was to our everlasting benefit that the Creator loosed the tongue of our first ancestor so that he might name all the things which the Almighty had put in the world around him, and all the spiritual images which He had implanted in his soul and so enrich his spirit by endlessly combining this wealth of names. By means of words we have dominion over all of nature; by means of words we acquire with ease all the treasures of the earth. Yet words cannot call down into our hearts the invisible spirit which reigns above us.

We gain power over worldly things by naming them; but if we hear of God's boundless goodness or of the virtues of the saints—subjects which should overwhelm our whole being—our ears merely ring with empty sound and our spirits are not uplifted as they should be.

Yet I know of two wonderful languages through which the Creator has granted man the means of grasping and comprehending the Divine in all its force, at least (not to appear presumptuous) insofar as that is at all possible for poor mortals. These languages speak to our inner selves, but not in words; suddenly and in wondrous fashion they invade our whole being, permeating every nerve and every drop of blood in our veins. One of these wonderful languages is spoken by God alone; the other is spoken only by a few chosen men whom He has anointed as His favorites. They are: Nature and Art.

Since my early youth, when I first encountered God our
Heavenly Father in our ancient books of holy scripture,
I have always looked to Nature for the fullest and clearest
explanation of His being and His attributes. The rustling
of treetops in a forest or the rolling of thunder told me
mysterious things about Him which I cannot put into
words. A lovely valley enclosed by fearsome crags, or
willows reflected in a smooth-flowing stream, or a mead-
ow, green and serene, beneath a clear blue sky—ah! these
things thrilled me more wonderfully, infused my heart
more deeply with the infinite power and bounty of God,
and purified and exalted my soul far more than words can
ever do. Language, it seems to me, is too worldly and
clumsy a tool to convey things of the spirit as well as
material things.

I find in this great cause to praise the power and benev-
olence of the Creator. He has surrounded us mortals with
an infinite variety of things, each of which has its own
reality and none of which we can understand or compre-
hend. We do not know what a tree is, or what a meadow
is, or what a rock is; we cannot talk to them in our lan-
guage and we are capable of communication only among
ourselves. And yet the Creator has instilled in us such a
marvellous sympathy for these things that they fill our
hearts in unknown ways with feelings or sentiments or
whatever we may wish to call those intimations which not
even the most precise words can convey to us.

The worldly-wise have been led astray by an otherwise
admirable love of truth. In their desire to uncover the
secrets of Heaven and to bring them down to earth and
cast earthly light upon them, they have banished from
their breasts those vague feelings which they once had for

them, and they have justified this procedure quite vehemently. —Can puny man explain the secrets of Heaven? Can he drag into the light of day what God has veiled in darkness? Can he in his arrogance dismiss those indistinct feelings which descend to us from Heaven like angels in disguise?—I honor them in deep humility; for it is only by divine grace that these genuine witnesses of truth come down to us. I fold my hands in adoration.

Art is a language quite different from nature, but it too, in similar mysterious and secret ways, exercises a marvellous power over the human heart. Art speaks through pictorial representations of men; that is, it employs a hieroglyphic language whose signs we recognize and understand on sight. But in the figures which it presents, the spiritual and the sensuous are merged in such an effective and admirable fashion that the whole of our selves and every fiber of our being is doubly moved and shaken utterly. It would be no exaggeration to say that many paintings portraying Christ's Passion or the Holy Virgin or the lives of the Saints have purged my soul more pure, and inspired more divinely virtuous sentiments in my heart than systems of moral philosophy or pious sermons ever have. One work among others which I still recall with emotion is an exquisite painting of Saint Sebastian standing naked and bound to a tree while an angel draws the arrows from his breast and another angel descends from heaven with a garland of flowers for his head. To this painting I owe the most profound and lasting Christian sentiments, and even yet I can scarcely recall its details without tears coming to my eyes.

The teachings of the wise stir only our intellects, only one half of our selves. But the two wonderful languages

whose power I here proclaim touch our senses as well as
our minds, or rather (I cannot express the thought other-
wise) appear in the process to merge every part of our
being (so mysterious to us) into one single new organ of
perception, which in this twofold way grasps and compre-
hends heavenly mysteries.

One of these languages, which the Almighty Himself
speaks from everlasting to everlasting—eternal, infinite
Nature—, raises us through the immensities of space into
the presence of God Himself. Art, however, which by the
meaningful combination of colored earth and a little mois-
ture recreates the human shape in ideal form within a
narrow, limited sphere (a kind of creative power which
was vouchsafed to mortals)—art reveals to us the trea-
sures of the human breast, turns our gaze inward, and
shows us the Invisible, I mean all that is noble, sublime,
and divine in human form.

When I leave the consecrated chapel of our cloister
where I have been meditating upon Christ on the cross
and step out into the open air where the sun shines down
from a blue sky, enveloping me in its warmth and vitality,
and when the beauties of the landscape with its moun-
tains, streams, and trees impinge upon my vision, then I
see a unique and divine world unfolding before me and
feel great things stirring strangely in my breast. And when
I leave the outdoors and enter the chapel again, and with
earnest fervor contemplate the painting of Christ on the
cross, then I see another unique but different divine world
unfolding before me and feel great things stirring in my
breast in a similarly strange yet different fashion.

Art depicts man in his most perfect form. Nature—at
least as much of it as is visible to our mortal eye—is like a

fragmentary oracular utterance from the mouth of the Divinity. If one may speak so familiarly of such things, one might perhaps say that in a sense the world of nature or the entire universe is to God what a work of art is to man.

Concerning the Peculiarities of the Ancient Painter Piero di Cosimo of the Florentine School

Nature, in her ceaseless diligence, creates with her ever-active hands a million creatures of every species and casts them into life on earth. Playfully and whimsically, she takes whatever substances are available and blindly mixes them in countless different ways, regardless of how they combine, then abandons each creature which proceeds from her hands to its own peculiar joys and torments. And just as in the realm of the inanimate she sometimes willfully creates strange and monstrous forms amidst a host of commonplace objects, so too every few centuries she produces a few oddities among the human race, whom she hides among thousands of normal people. Yet these strange beings perish and are forgotten like the most prosaic of men. Later generations whose curiosity has been aroused collect scattered, stammered words in chronicles, and these are supposed to describe them to us. Yet we can form no coherent picture, and never fully learn to understand them. After all, even those who saw them with their own eyes could not fully understand them; indeed, they

scarcely understood themselves. We can only contemplate them with idle admiration, which is ultimately all that we can do with anything on this earth.

These thoughts were inspired in me by my chancing upon the fascinating Piero di Cosimo in the histories of the ancient painters. Nature had implanted in his breast a fantasy in constant ferment and had drawn a cover of dark and gloomy storm clouds over his spirit, so that his soul was in a state of constant agitation, reveling in a prodigality of images without ever reflecting itself in serene and simple beauty. Everything about him was extraordinary and unusual, and the ancient writers cannot find words forceful enough to convey a notion of the extravagance and monstrosity of his whole being. Yet we find in their works only a few scattered references to character-traits, some of which seem insignificant enough in themselves. These by no means provide penetrating insights into the abyss of his soul, or merge to form a complete and coherent picture, though they do manage to suggest, however dimly, greater depths beneath the surface.

Even in his youth Piero di Cosimo possessed a lively and energetic disposition, and a teeming imagination which early distinguished him from his fellow apprentices. His soul was never content to concentrate on one thought or one image alone. A host of strange and alien ideas was forever swarming through his brain, transporting him out of the present. Sometimes, when he was simultaneously working and recounting or explaining something, his imagination, which was forever reveling freely abroad, would imperceptibly lead him to such abstruse heights that he would suddenly lose all orientation, falter, and have to start from the beginning again. He

loathed human society, and most of all loved gloomy iso-
lation where, with thoughts turned inward, he could fol-
low the flights of his imagination wherever they might
lead. He always kept to himself in a locked room and led a
mode of existence peculiarly his own. He always ate the
same monotonous meals, which he would prepare for
himself at any hour of the day, whenever the spirit moved
him. He would not allow his room to be cleaned and he
also refused to have the fruit trees and vines in his garden
pruned, for he wanted to see wild, unrefined, untamed
nature everywhere, and took pleasure in what is repulsive
to men of sensibilities different from his. For instance, he
had a secret fascination for lingering beside any mon-
strous animals or plants, any aberrations in physical na-
ture. He would observe them with rapt attention, savor-
ing their ugliness, and later he would keep recalling their
appearance, unable to banish them from his mind, how-
ever abhorrent they might become to him in the end.
With time he had filled a whole book with such misshapen
creatures, which he sketched with accuracy and diligence.
Often too, he would stare at walls stained and mottled
with age or at clouds in the sky, and his imagination
would derive from such haphazard configurations in na-
ture many a bold idea for wild cavalry battles or grandiose
mountain landscapes with fantastic cities. He would expe-
rience enormous pleasure in torrential rains thundering
off the roofs onto the pavements—though he was as fright-
ened as a child of thunder, and when a thunderstorm was
raging in the heavens would wrap himself up tightly in
his cloak, close the windows, and crawl into a corner of
his house until it had passed. The crying of little children,
the ringing of church bells, and the singing of monks

could make him half demented. His manner of speaking was extraordinary and colorful, and indeed he sometimes said such extremely funny things that his listeners would almost explode with laughter. In short, he was so made that his contemporaries took him for a most confused fellow, for a madman almost.

His spirit, which was constantly bubbling and frothing and spuming like water on the boil, had an excellent opportunity for displaying itself in every kind of new and novel invention in the masquerades and fanciful processions which took place in Florence during the Carnival period, and it was, indeed, through him that this festival first acquired the reputation which it later enjoyed. Among all the extraordinary and widely admired festive processions which he organized, however, one was so special and unusual that we will give a brief account of it here. The preparations had been made in secret, so that all of Florence was utterly surprised and shaken by it.

On the night of the celebration, when the populace was reveling through the streets of the city in a riotous abandon of joy—suddenly the mob scattered in terror and looked around themselves in dismay and astonishment. Through the gloom of the night there slowly rolled up an enormous black cart, drawn by four black oxen, and marked with white crosses and bones of the dead, and on the cart there strutted the colossal figure of Death Triumphant, armed with his dreadful scythe, with a pile of coffins at his feet. The lumbering procession drew to a stop, and to the mournful sound of weird horns, whose terrifying wail pierced the bone to the marrow, and in the bewitching flicker of distant torches, there slowly stepped out of the opening coffins (a sight overwhelming everyone

with speechless terror), white skeletons who sat down on the coffins and filled the air with a melancholy dirge, which mingled with the notes of the horns to curdle the blood in the veins. They sang of the horrors of death, and that all those people who were then alive and looking at them would soon be skeletons like them. All around and behind the cart there was a great milling throng of dead, with masks resembling skulls on their faces, wearing black cloaks marked with white bones and crosses, and mounted on haggard horses—and each one had a retinue of four other black horsemen, carrying torches and monstrous black flags marked with skulls and bones and white crosses. The cart was draped with ten immense black flags, and as the procession crept slowly forward, the whole host of the dead sang a Psalm of David with tremulous hollow voices.

It is quite remarkable that this unexpected procession of the dead, despite the widespread terror which it occasioned at first, was nevertheless received with enthusiastic acclaim by all of Florence. Painful and repulsive sensations force their way into the soul, holding it fast and compelling it into a state of sympathetic participation; and when they also assail and excite the imagination with a certain poetic flair they can keep the soul suspended in a mood of sublime exaltation. I would like to add to this, incidentally, that Heaven seems to implant in remarkable personalities like this Piero di Cosimo the wonderful and mysterious power of firing the imagination even of the vulgar throng by their strange and extraordinary acts.

Although Piero was constantly irritated, plagued, and exhausted by his restless and gloomy imagination, Heaven had decreed that he should live to a ripe old age, and as

he approached his eightieth year his spirit was pursued by even wilder fantasies. He continued to suffer his torment in isolation, however, despite his great physical weakness and all the miseries of old age, and he vehemently refused any company or help proffered out of pity. And then he would try to continue working, but could not, because his hands were crippled and constantly trembling. At such times he would fly into a vicious rage and would try to do violence to his hands, but as he muttered furiously to himself his maulstick or even his brush would fall to the floor, a pitiful sight to behold. He could quarrel with his own shadow or become infuriated at a fly. Though he continued to deny that he was near his end, he spoke at great length of the wretchedness of a slow death, inexorably consuming the body with a thousand tortures and killing off one drop of blood after another. He cursed doctors, apothecaries, and nurses, and described how terrible it was when a man could neither eat nor sleep, when he had to make his will and see his relatives stand around his bed in tears. By way of contrast, he would call that man fortunate who at one blow of the executioner's axe is dispatched out of this life and into the next; and he would proclaim the beauties of ascending to the angels in Paradise before the eyes of so many people, accompanied by the consolations and prayers of the priest and the supplications of thousands. He would rhapsodize endlessly on such a subject—until finally, one morning, he was unexpectedly found lying dead at the foot of the stairs in his house.

These, then, are the curious spiritual lineaments of this painter, which I have copied faithfully from Giorgio Vasari. As far as Piero's paintings are concerned, the same

author relates that he loved most of all to depict wild Bacchanals and orgies, dreadful monsters, and other terrifying images, though at the same time Vasari praises the singular meticulousness and application of his work. Vasari, in fact, remarks in the context of another similarly melancholic painter° that gloomy and hypochondriacal spirits of this sort are often noted for their inexhaustible patience and diligence.

However that may be, I cannot believe that this Piero di Cosimo truly possessed the genuine artistic temperament. It is true that I find a certain resemblance between him and the great Leonardo da Vinci (on whom he also modeled himself as a painter), for both were impelled by a tireless, versatile spirit; but while Piero ranged the nebulous and dismal regions of the air, Leonardo was at home in the real world of nature and in the commotion of real life.

To my mind, the artistic temperament should be no more than a functional aid for perceiving nature in its totality and infusing it with the human spirit so that it may be born again in beautifully transfigured form. If, however, from some deep impulse or from an excess of wild and exuberant vitality it is at all times restlessly active, then it is not always an efficient tool. Rather might one regard it as then being itself a kind of artwork of creation.

The heavens are not reflected in raging and foaming seas; it is in the clear stream that trees and cliffs and drifting clouds and all the stars of the firmament are pleased to contemplate their reflections.

°The Florentine Giovanni Antonio Sogliani

*How and in What Manner We Ought Properly to
Contemplate the Works of the World's Great
Artists and Employ Them for the Benefit
of Our Souls*

𝕵 continually hear foolish and frivolous persons lament
that God has bestowed so few truly outstanding artists
upon the world, and these same vulgar minds stare impa-
tiently into the future to see whether the Heavenly Father
might not be about to create a new race of brilliant paint-
ers. I, however, declare that the earth has suffered no
dearth of excellent masters. Some, indeed, are such that
a mortal might spend his whole life contemplating and
comprehending just one of them. What is only too true,
however, is that there are far, far too few people capable
of really understanding or (what amounts to the same
thing) sincerely venerating the works of those beings
formed of a nobler clay.

Picture galleries are commonly regarded as fairs at
which we can judge, praise, or condemn new wares in
passing, while they ought to be temples where, in serene
and self-effacing silence and in solitary exaltation, we may
admire the great artists, those most sublime of mortals,
and warm ourselves in the sunshine of rapturous thoughts
and sentiments in prolonged and tranquil contemplation
of their works.

The appreciation of sublime artworks is akin to prayer.
God takes no pleasure in the man who speaks to Him only
to absolve himself of a daily duty, counting every word
mindlessly, and boastfully measuring out his piety on the

beads of his rosary. Yet Heaven smiles upon the man who in yearning submission awaits the chosen hour when the divine light gently descends upon him unforced, shattering the shell of earthly imperfection which commonly overlies the human spirit, and dissolving and laying bare his nobler self. Kneeling down, he opens his heart and turns it in silent rapture toward the divine radiance, filling it with celestial light. Then, when he arises, he feels at once happier and more wistful, lighter and yet fuller of heart, and turns his hand to good and noble works. That is what I consider true prayer to be.

To my mind, we ought to approach masterpieces of art in like manner in order fittingly to employ them for the benefit of our souls. It is nothing short of blasphemy for a man to reel away from the ringing laughter of his friends in a worldly hour so that he may talk for a few minutes with God in a nearby church out of mere habit. It is no less blasphemous in such an hour to cross the threshold of the building where—in silent testimony to the dignity of the human race—are preserved for eternity the most admirable creations which the hand of man has wrought. Wait, as you would do in praying, for those moments of bliss when divine grace illumines your soul with a nobler revelation, for only then will your soul merge into one with the works of the artists. Their magical figures remain silent and uncommunicative when you look at them coldly. Your heart must first address them forcefully if they are to speak to you and exercise all their power over you.

Artworks are by their very nature as little part of the common flow of life as is the thought of God. They transcend what is ordinary and commonplace, and we must

raise ourselves up to their level in the fullness of our hearts for them to become in our eyes, all too often dimmed by the fog of our worldliness, what they truly and sublimely are.

Anyone can learn to read the letters of the alphabet; anyone can read and retell the histories of bygone ages recorded in learned chronicles; and anyone, too, can study a scientific system and grasp propositions and truths—for letters exist only so that the eye may recognize their shapes, and propositions and happenings command our attention only for as long as our inner eye takes to grasp and comprehend them. As soon as we have assimilated them, our mental activity is at an end, and we delight in an indolent and profitless survey of our treasures only as often as this gives us pleasure. Not so with the works of sublime artists. They are not there so that the eye may see them, but so that we may enter them sympathetically, and live and breathe in them. An exquisite painting is not like a paragraph in a textbook, which I can cast aside like a worthless shell as soon as I have extracted its meaning with a little effort; rather does the pleasure to be derived from superb artworks last on and never end. We imagine that we are penetrating them more and more deeply, and yet they are forever exciting our senses anew, and we can see no end to their possibilities. There burns in them a vital oil which will not be extinguished in all eternity.

I hasten impatiently over first impressions, for the surprise of the new has always seemed to me a necessary evil involved in seeing a work for the first time, though there are many who, eager for an ever-changing variety of delights, would declare this to be the main purpose of art. Genuine enjoyment requires a calm and tranquil state of

mind and expresses itself not in loud exclamations or in the clapping of hands, but solely through inner excitation. It is a holy day of celebration for me when, earnest and composed, I go to look at sublime artworks. I return to them again and again, and they remain firmly imprinted upon my senses. As long as I walk this earth I will carry them around in my imagination as a kind of spiritual talisman, for they comfort and revive my spirit, and I will take them with me to the grave.

Once a man's finer sensibilities have been touched and become receptive to the mysterious charm inherent in art, his soul will often be deeply moved where another man will pass by with indifference. For as long as he lives, his soul will know the joy of having frequent cause to be moved and excited beneficially. When, occupied with other thoughts, I am passing through some great and splendid portal, and my eyes are instinctively drawn to the mighty and majestic columns with all their sweet sublimity, so that my inner self is filled with wondrous sentiment, I am often conscious of bowing inwardly before them and of continuing on my way with my heart lightened and my soul enriched.

The most important thing is that in our arrogance we should not raise ourselves above the spirit of sublime artists and presume to pass judgment on them. This is a foolish manifestation of man's vanity and pride. Art is above man, and we can only admire and revere the splendid works of its votaries and open up our hearts to them so that all our feelings may be dissolved and purified.

The Genius of Michelangelo Buonarroti

𝕴 think that any man who has a receptive and loving heart has some favorite object in the realm of art to which he is preeminently drawn; and I, too, have mine, to which my spirit involuntarily turns time and again as the sunflower does to the sun. Often, when I am sitting contemplating in my solitude, it is as if a good angel were standing behind me and, unseen, were conjuring up before my eyes the great age of Italian art like a huge, richly-textured tapestry thronging with living figures. Again and again this vision of splendor appears to me, and each time my heart's blood flows faster. The ability to love and venerate is a precious gift of Heaven, for it melts our whole being and extracts its purest gold.

Today my gaze falls on the great Michelangelo Buonarroti, a man who has already been the object of so much speechless admiration, as well as of insolent derision and censure. But I cannot begin to speak of him with fuller heart than his friend and compatriot Giorgio Vasari, the opening lines of whose biographical account reads word for word as follows:

"Following the precepts of the illustrious Giotto and his adherents, many thoughtful and excellent artists struggled to give the world proof of the talent which the benevolent stars or the fortunate constellation of their intellectual powers had created in them by striving to reproduce the splendors of nature through a perfection of their artistry, so that they might attain the highest summit of knowledge, which deserves the simple name of 'Perception.' Yet

their exertions were in vain! Seeing all this prodigious waste of energy and effort, all this infinite but quite fruitless passion for learning, and the conceit of men as far removed from truth as darkness is from light, the Almighty in His mercy resolved to deliver us from such delusions by sending down to earth a spirit who, by his own powers, would become an outstanding master in every branch of every art. By his example, he was to teach mankind the meaning of perfection in the arts of drawing, draftsmanship, and chiaroscuro (by means of which paintings capture the fullness of life); he was to show, too, how a discriminating sculptor must work, and how buildings should be invested with stability, comfort, beauty of proportion, charm, and wealth of architectural embellishment. Over and above this, however, Heaven gave him virtue and wisdom as companions and the sweet art of the Muses as an adornment, so that the world might revere him more as a heavenly than as an earthly being; and that we might admire him before all men and choose him as a model and exemplar in our lives and work, in our moral conduct, and, indeed, in all our worldly dealings. And because God saw that especially in the arts of painting, sculpture, and architecture—endeavors requiring so much diligence and application—the natives of Tuscany had since time immemorial achieved such supreme mastery (for more than any other race in Italy they are singularly inclined to industry and to every sort of strenuous intellectual activity), he decided on Florence as the city most worthy to be his home, so that the deserved crown of all virtues might be placed on his head by a fellow citizen."

Such is the veneration with which old Vasari speaks of

the great Michelangelo, and in beautiful and human fash-
ion his final words compress his limitless admiration for
him into a heartfelt expression of patriotic pride and of
intense pleasure at having shared the same little plot of
earth as home with this man whom he reveres as a Hercu-
les among the heroes of art. He describes the life of Buo-
narroti in minute detail, often revealing his own good-
natured pride at having enjoyed his intimate friendship.

Yet it is not our intention merely to marvel at this great
man, but rather to penetrate his inner self and to feel our
way into the unique character of his works. It is not
enough to praise an artwork as being "excellent and beau-
tiful," for these generalities can be applied with equal jus-
tification to the most diverse works. We must give our-
selves over entirely to every great artist, contemplating
and comprehending natural objects through his eyes, so
that we may enter his very soul and be able to say: "This
work is in its own fashion accurate and well-founded."

Painting is a kind of poetry employing images of men.
In painting, as in poetry, different artists breathe quite
different feelings into their works, in accordance with the
spirit which the Creator has breathed into them. Some
poets transfuse their entire works with a calm and myste-
rious poetic soul, while in others an abundance of exuber-
ant poetic vigor bursts forth at every turn.

It is this difference that I notice between the divine
Raphael and the mighty Buonarroti. I should like to call
Raphael the painter of the New Testament, and Buo-
narroti the painter of the Old Testament; for on the first
there reposes the divine and tranquil spirit of Christ (if I
may be so bold as to make such an audacious pronounce-
ment), while on the second there reposes the spirit of the

inspired prophets, of Moses and the other poets of the Orient. This is cause neither for praise nor for censure, for each is merely as he is.

Just as the inspired poets of the Orient were impelled to preternatural fantasies by the mighty stirrings of the divine power dwelling within them, and from an inner urging and by means of a proliferation of fiery images forced the words and expressions of earthly language up into the celestial sphere, as it were, so too Michelangelo was constantly in the grip of prodigious and monstrous forces, and expressed a superhuman tension and energy through his figures. He liked to attempt sublime and terrifying subjects and would venture the most provocative and frenzied arrangements and gestures in his paintings; he painted muscle over muscle, and tried to imprint in every nerve of his figures the exalted poetic fervor with which he was overflowing. He traced down the inner workings of the human machine to the most minute causes; he sought out the most complex difficulties in the mechanics of the human body in order to pit himself against them, and in order to satisfy his vast intellectual powers by giving them free rein in the physical aspects of his art—just as poets in whom there burns an unextinguishable lyrical fire are not satisfied with grand and prodigious ideas alone, but are also particularly intent to impress their bold and frenzied vitality upon their style and language, the visible and sensuous functional aspect of their art. The effect in either case is grand and dazzling, for the inner spirit of the whole beams forth from every material facet.

This is how I understand the controversial Buonarroti to be, and whoever sees him in this light among the old

painters may well ask in astonishment and admiration who painted before him as he did. Where did he acquire that unprecedented grandeur which no eye beheld before him? And who directed him to these untrodden paths?

There is in the world of art no nobler object, and no object more worthy of veneration, than an original genius. To work with diligence and application, with objectivity and intelligence is *human;* but to penetrate the very essence of art with a new vision, to approach it from a completely different direction as it were, is *divine.*

It is, however, the destiny of genius to spawn a horde of despicable imitators, a fate which Michelangelo correctly foretold for himself. With one bold leap the genius propels himself to the farthest reaches of his art, and stands there boldly and firmly, holding up to our gaze what is extraordinary and wonderful. But given man's limited intellect, there is scarcely anything extraordinary and wonderful which may not inspire mere foolishness and insipidity. These lamentable imitators, lacking the strength to stand firmly on their own feet, wander around blindly, and their imitations, if they are ever more than pitiful shadows of the original, are distorted exaggerations.

The age of Michelangelo, the earliest period of Italian painting, is the only period in history possessing truly original painters. Who painted like Correggio before Correggio, or like Raphael before Raphael? Yet one would think that nature, in her prodigality, had squandered all her wealth of artistic genius during this period, for with very few exceptions the outstanding masters of later years, down to and including the present day, have had no objective other than to imitate one or another (or even several together) of those early original standard-setting

painters, and they have not easily achieved greatness except through the excellence of their imitations. Even the considerable and deserved fame which the reformers Caracci and their school earned for themselves rests on no merit other than that by offering worthy examples, they restored to eminence the art of imitation which had fallen into decay. And whom did the old masters themselves imitate? They created all that unprecedented splendor out of themselves.

Letter from a Young German Painter in Rome to His Friend in Nuremberg — *Tieck*

Dear Brother and Comrade,

An age, I know, has passed since I last wrote to you, though I have often thought of you with tender affection. There are times in our lives when external events follow upon each other too slowly for our speeding thoughts, when the soul is consumed with new ideas, and for that very reason nothing outward occurs. I have just lived through such a period, and now that my tranquility has been restored somewhat I will immediately reach for my pen and report to you, my beloved Sebastian, trustiest friend of my youth, how I have fared and what has befallen me.

Shall I describe at length conditions in the Promised Land of Italy and pour out my heart in incoherent praise? Words cannot fully express what I feel,

for how can I, so totally unskilled in writing, adequately portray the bright skies and the vast prospects of this paradise fanned by playful and refreshing zephyrs, when even in my own craft I can scarcely find colors or brushstrokes to sketch onto the canvas what I see and grasp with my inner eye.

Different though everything is here in heaven and earth, however, it can be more easily sensed and credited than what I have to tell you about the country's art. You, my dear Sebastian, and our beloved teacher Albrecht Dürer may paint as meticulously as you please up there in Germany, but if you were suddenly transported to this place you would truly be like two departed souls who had not yet adjusted to Heaven. In my thoughts I can see the artful Master Albrecht sitting on his stool, carving an intricate little piece of wood with childish, almost touching diligence, reflecting ponderously on his subject and its effectuation, and looking again and again at the artwork which he has begun. I can see his spacious paneled room with its round-paned windows, and you copying one of his works with boundless industry and fidelity. I can see, too, the younger apprentices walking to and fro, and old Master Dürer interjecting many a wise and many a merry word. Then I see Mistress Dürer come in, or the eloquent Willibald Pirckheimer, who inspects the paintings and drawings and begins a lively dispute with Albrecht. And when I imagine all of this in detail I really cannot understand how I have come to this place and how everything is so different here.

Do you still remember when we were first en-

trusted to our master as apprentices and we simply
could not understand how a face or a tree could grow
out of the colors which we were grinding? With what
astonishment did we then watch Master Albrecht,
who always knew how to employ everything so well
and was never at a loss how to execute his greatest
works! I was often as if in a dream when I left the
workroom to buy wine or bread for him, and when
other, unartistic men, such as tradesmen or farmers,
passed me by in the street I often could not help
thinking that he must surely be a magician that life-
less matter should take shape at his command and
come to life as it were.

Yet Heaven alone knows what I would have said or
felt then if Raphael's transfigured faces had been
revealed to my childish eyes. Ah! my dear Sebastian,
if I had understood them I would surely have sunk to
my knees and in the fullness of my young heart
would have dissolved in devotion, tears, and adora-
tion. Despite everything, you see, one can still per-
ceive the earthly element in our great Dürer. One can
understand how an artful and skillful man might
light upon these faces or arrive at these inventions,
and if we look very closely at his pictures we can
almost dismiss their painted figures and uncover the
empty, unadorned panel beneath. With Raphael, on
the other hand, my dear Sebastian, everything is con-
trived so wonderfully that you quite forget that there
is any such thing as paint or painting, and inwardly
you can feel only humility and the warmest love for
his heavenly and yet so profoundly human figures
and devote your heart and soul to them. Do not imag-

ine that I am exaggerating out of youthful ardor, for you cannot imagine or grasp these things unless you come and see them with your own eyes.

Altogether, my dear Sebastian, art makes of this earth the most splendid and delightful of abodes. Only now have I come to feel how there dwells in our hearts an invisible spirit which is irresistibly moved by great works of art. And if I am to tell you everything, dear friend of my youth (as indeed I must, for I feel an overwhelming impulse to do so), then I must reveal that I am now in love with a girl who is dearer to my heart than all other things, and I am loved by her in return. My senses, then, whirl intoxicated through the glories of an eternal springtime, and in moments of rapture I am almost capable of believing that the world and the sun in the sky borrow their brilliance from me, if it were not too presumptuous to express my joy in such a way. I have long been fervently seeking her features in the best paintings and have always found them in my favorite masters. I am betrothed to her, and in a few days we will celebrate our marriage. You can understand then that I have no desire to return to our native Germany, but I hope to embrace you soon here in Rome.

I cannot convey to you how unceasingly concerned for my spiritual welfare Maria was in her heart when she learned that I, too, had sympathies for the teachings of the Reformers. She often implored me to return to the old and true faith, and her loving speeches wrought havoc with my imagination and with all my supposed convictions. Tell our beloved Master Dürer nothing of what I am now about to relate to you, for

I know that it would only grieve his heart and would benefit neither him nor me.

Some time ago I went into the Rotunda, where, it being a feast day, a magnificent Latin mass was to be sung. Or perhaps my real reason for going was only to see my sweetheart among the worshippers and to derive inspiration from observing her at her pious devotions. The superb church, the crowds of people who came thronging in and who gathered around me in ever-increasing numbers, the splendors of the preparatory ceremonies—all of this made me peculiarly attentive. I felt very solemn, and even though—as is usual in such a tumult—I was unable to think clearly or distinctly, there was a strange turmoil within me, as if something extraordinary were about to happen. All at once the congregation fell silent, and above us the mighty music soared in long, slow, full notes, as if an invisible spirit were moving above our heads. The music surged over us, submerging us in ever-greater waves, like an ocean of sound, and drawing my very soul out of my body. My heart throbbed, and I felt an irresistible longing for something noble and sublime that I might embrace. My spirit was uplifted by the sonorous Latin anthem, which, rising and falling, made itself heard through the swelling of the music, like a ship sailing through the waves of the sea. And as the music permeated my whole being and coursed through my very veins, I raised my dreaming eyes and looked around me— and the whole church became alive to my gaze, so intoxicated was I by the music. At that moment the music stopped. A priest stepped up to the High Altar,

held up the Host with a rapturous gesture, and exposed it to the view of the multitude—and they all fell to their knees, and trumpets and I know not what other mighty instruments thundered and sounded, sending a shudder of divine ecstasy through me. Everyone around me knelt, and a power, mysterious and mystic, forced me irresistibly to my knees, and I could not have withstood it even though I had tried with all my might. And as I knelt with head bowed, my heart pounding in my breast, an unseen force lifted up my eyes again. I looked around, and it was as if all these Catholics, men and women, on bended knees, their gaze turned inward or raised to Heaven, crossing themselves fervently, striking their breasts, or moving their lips in prayer—it was as if this multitude around me were commending my soul to our Heavenly Father, as if they were praying for the one lost sheep in their midst, and in their pious devotion were irresistibly drawing me over to their faith. I looked to the side and caught sight of Maria. Her glance met mine, and I saw tears of holy compassion come to her blue eyes. I knew not how I felt, I could not bear her gaze, and I averted my eyes. They came to rest upon an altar with a painting of Christ on the cross who looked at me with inexpressible sorrow. And the mighty columns of the church, like venerable apostles and saints, gazed down upon me majestically with their capitals—and the vast dome hovered over me like the all-embracing heavens and gave its blessing to my pious resolve.

When the solemnities were over I could not leave the church. I threw myself down in a corner and

wept, and with a heart full of remorse I looked at all the saints and all the paintings as if I were seeing them and honoring them for the first time.

I could not withstand the power which had been awakened within me. My dear Sebastian, I have now gone over to the Catholic faith, and my heart feels light and gay. It was the irresistible power of art which won me over, and I can honestly say that it is only now that I have begun to understand art and grasp its essence. If you can tell me what has so transformed me, what has moved my soul as if with the tongues of angels, then give it a name and enlighten me as to my own condition. I have followed only my instincts, the urgings of my blood, every drop of which now seems purer to me.

Ah! even in the old days, did I not believe those stories of saints and miracles which seem unfathomable to us? Can you rightly understand a sacred picture and look at it with pious devotion without at the same time believing in what it depicts? And what harm can come of it if this poetic force residing in sacred art is longer lasting in its effect on me?

Surely your heart will not turn away from mine, for that is not possible, Sebastian. And so, let us pray to the same God that henceforth He may enlighten our spirits more and more and pour down true piety upon us. What goes beyond this shall not and cannot separate us. Is that not so, friend of my youth?

Farewell, and convey my cordial greetings to our master. Even though you do not share my views, this letter must bring you joy, for it tells you that I am happy.

The Portraits of the Artists

The muse enters the picture gallery
in the company of a young artist

The Muse

Linger here serene and calm and solemn,
In the friendly presence of those men
Who have filled your heart with plenteous love,
Masters who endear you through their works.
Stop here now and contemplate their faces.

The Youth

How they entrance me!
How my heart thrills
To meet their sweet, delightful gaze!
And yet, alas! how humbled I feel
That all direct their earnest eyes
At me, an alien in their midst.
How close I feel to all of you,
And yet how far removed!
Boldly now would I grasp my brush,
And paint grand and splendid figures
With unwavering hand and glowing colors.
And yet I scarcely dare
To look into the eyes of this great master here.
I feel as if spellbound, cast among spirits,
And a wondrous luster falls
From all the paintings here
Into my darkling, yet expectant soul.

Who was this sage
Of friendly mien, heavy with thought,
Reposing in the weight of his own grandeur here?

The Muse

The long silvery hair which crowns the head
Of this painter, merging with his beard,
Was the glory of the wise Leonardo,
Founder of the famous school in Florence.

The Youth

Blessed be the hand which has with zealous effort
Preserved this precious head for us.
Yes, this was indeed Leonardo:
Now deep in thought; now gazing into Nature's
 vastness;
And then again engaged
In endless struggle for new knowledge.
Yet who is this,
In gaze and pose almost his twin,
Yet earnest and more locked within himself?

The Muse

Albrecht Dürer, who served me well,
Prayed to me as to a saint with fervor
Once, when in the wild and distant North
People despised me and my art. Pious and
Simple were his ways, like those of children.
Even as he was, are all his paintings.

The Youth

Yes, this is the calm and industry,

This the noble modesty of that honored man,
And this the inner working of his spirit.
Yet tell me the name of this man here,
Whose furious gaze pierces my soul
And makes me shudder when I look upon him.

The Muse

This here was the pride of his homeland,
Precious jewel of Tuscany, and wonder
Of posterity. See the strength of
Michelangelo Buonarroti.

The Youth

Ah! what strength! The might of a lion!
A man familiar with terror and the sublime!
But longing drives me on, and ever on.
Restless, my gaze wanders around the walls,
And yet it cannot find what I most seek.
No eye is deep or earnest,
No brow is noble or inspired enough.
Perhaps to the side, alone, with flowing beard,
His gray hairs crowned with saintly halo,
I shall see the godly Raphael.

The Muse

This youth here was Raphael.

The Youth

This youth?—Unfathomable, Lord,
Are Your ways!
Unfathomable the sublime wonders of art!
This serene, unclouded eye

Looked upon self-created images
Of Christ, Madonnas, Saints and Apostles,
And ancient sages and wild battles!
And yet he seems no older than myself.
On simple, childish themes he seems to meditate.
And yet reflection seems light work to him.
What warmth and close affinity I feel for him!
No hoary-headed pride or earnestness
Rejects my inexperience.—How I should like
To sink upon his breast and melt in tears of joy!
Ah! I know he would enfold me in his arms
And seek to comfort me
In my rapturous good-fortune.—
Yes! I shall let my tears flow freely.—
Art in you reveals to man
Her divinity in fairest form.

The Painters' Chronicle

When in the days of my youth I was given to aimless
and restless wanderings and eagerly seized upon every
opportunity of inspecting whatever artworks were to be
seen anywhere, I once found myself in a count's castle
with which I was unfamiliar and where for three days on
end I could not feast my eyes enough on the numerous
pictures on display. I wanted to get to know them all by
heart, and in the excitement my blood became so over-
heated that the thousand diverse pictures quite confused

my mind. On the third day an old man arrived at the castle, an itinerant Italian priest, whose name I have been unable to discover to this day and from whom I have heard nothing since. He was a profoundly learned man, and I was astonished at the wealth of knowledge which he carried in his head. In appearance he reminded me of some sixteenth-century humanist scholar, and although I was still such a young man then, he did not scorn to engage me in friendly conversation (there must have been something about me that he liked) and spent the whole day walking around the picture gallery with me.

When he saw the great enthusiasm with which I examined the paintings, he asked me whether I could name the masters who had painted this or that work. I answered that I knew the most famous of them well enough, at which he asked me further whether I knew anything more about them than their names. When he saw that I really did not know more about them than just that, he began as follows:

"So far, my dear son, you have marveled at these beautiful paintings as if they were miracles which had fallen down to earth from Heaven. But consider that these have all been wrought by the hand of man, that many an artist produced works of surpassing excellence when he was no older than you are now. Now, what do you say to that? Does it not make you wish that you knew something more about the men who excelled in the art of painting? It inspires wonderful thoughts in us when we consider how their works shine on forever in undiminished splendor, while the artists themselves, in their lives and in their deaths, were men like us, except that in them there burned a unique divine fire for as long as they lived. Con-

siderations of this sort transport us into a pensive and dreamy mood in which diverse good thoughts never fail to pass through our minds."

I can still remember distinctly and with the most heart-felt pleasure every single word which the dear old man spoke, and so I will try to record some more of his words.

When he saw that I was listening quietly and attentively, he continued more or less as follows:

"I have noticed with pleasure, my son, that your heart is strongly attracted to the excellent Raphael. Now, imagine that you were standing before one of his most magnificent paintings, looking with veneration at every brush-stroke, and thinking: 'If only I had seen the saintly man while he was alive! How I would have adored him!' And imagine that at the same time you could hear the old chronicler of the painters tell of him as follows: 'This Raphael Sanzio was his parents' only son. His father loved him dearly and insisted that his mother should suckle him with her own milk so that he would not be given out to common people to be nursed. And when he grew up he helped his father at his work as a tender son should, and his father was happy that he did his work so well. But so that he might receive proper instruction, he reached an agreement with Master Pietro of Perugia that this painter should accept him as an apprentice, and joyfully he took him to Perugia in person, where Pietro accorded the boy a most friendly reception. His mother, however, had wept bitterly at their parting and could scarcely tear herself away from the child, for she too loved him with all her heart.' Now, tell me! How do you feel when you hear that? Is it not sweet and comforting to hear these things? —And this was the same man who after thirty-seven short

years lay cold and white in his coffin, lamented by the whole world. The body was laid out in his workroom, and an exquisite funeral poem, the divine painting of the Transfiguration, stood on its easel beside the coffin—the same painting in which even today we can still see portrayed in such glorious union the misery of the earth, the consolation of noble-minded men, and the glory of the Kingdom of Heaven. And the master by whom it had been conceived and executed lay beside it cold and white."

I was utterly delighted by these things and asked the stranger to tell me more about Raphael.

"The highest praise that I know of him," he answered, "is that Raphael the man was just as noble and lovable as Raphael the artist. He had none of that sinister or prideful demeanor of other artists, who often go to great lengths to assume every kind of eccentricity. In all his earthly dealings he was simple, gentle, and serene, like a flowing stream. So amicable was he that when artists whom he knew only slightly or not at all asked him for drawings by his hand, he would leave his work and attend to them first. He helped many in this way, and advised them like a father, most lovingly. His outstanding artistic abilities brought together around him a group of painters eager to be his pupils, though some of them had already completed their apprenticeships. They formed a large retinue which would accompany him whenever he left his house to go to court. However, so many painters of differing views would certainly not have been able to live together without conflict or discord if the spirit of their great master had not shone upon them magically like a sun of peace, banishing all impurity from their souls. And so they

bowed to the supremacy both of his spirit and of his brush.

"A beautiful legend, too, is told of Raphael's life, which goes as follows. He once painted for a monastery in Palermo an exquisite picture of Christ carrying the cross. However, the ship in which it was being transported was struck by a violent storm and shipwrecked. Men and goods were lost, and only this painting—it was a special dispensation of Providence—only this painting was borne by friendly waves into the harbor of Genoa, where it was removed from its packing case quite undamaged. Even the wild elements, then, showed their reverence for the saintly man. Thereupon the painting was taken to Palermo, where, in the words of old Vasari, it is valued as a jewel of the island of Sicily no less precious than Mount Etna."

My delight increased with each splendid story that he told, and I shook the priest's hand warmly and asked him eagerly where he had learned all these things.

"You should know, my son," he answered, "that several worthy men have kept chronicles of art history describing the lives of the painters at length, and the oldest and, at the same time, probably the most distinguished of these is called Giorgio Vasari. Few men read these books nowadays, though much wit and wisdom are hidden in them. Just think what a fine thing it is to get to know the various personalities and habits of those men whom you already know from their various ways of handling the brush. Both views will then merge into one picture in your mind. And if you approach these dry narratives with the deep passion which they deserve, then a splendid vision will arise before your eyes, namely that of the *artistic character,*

which will afford you a totally new and delightful spectacle as it reveals its countless facets in a thousand different individuals. Every character will become a different painting for you, and you will have collected around you a magnificent portrait-gallery in which to mirror your spirit."

At that time I did not yet properly understand his words, though later, once I had read the books which he mentioned, they came to express my own opinion. Meanwhile, I implored the good old priest to tell me even more beautiful stories from the painters' chronicle. "Let me see then," he said with a smile. "I love to talk about the old painters' lives." And now indeed he told me a whole series of the most beautiful histories, for he had read many times all the books which had ever been written about art and knew the best parts of them by heart. For me, his tales were so absorbing that I can still remember them almost word for word, and I will tell some of them again for your pleasure.

When he came upon a painting by the admirable Domenichino in the gallery in which we were standing, he said that this painter afforded a remarkable example of passionate involvement in art, and to demonstrate this he continued as follows:

"Before this master began a painting he would first give lengthy preliminary consideration to it and would often spend entire days alone in his room until every last detail of the picture was complete in his mind. Then he was content and would say that the work was now half finished. And once he had taken the brush in his hand he would stand fixed to the spot in front of his easel for another whole day, and would scarcely stop for a few

minutes to eat. He painted with the greatest diligence and perfection and put profound expression into all his works. When someone once tried to persuade him not to torment himself like this but to adopt the lighter manner of other painters, he answered quite curtly that he worked only for himself and for the perfection of art. He could not understand how other painters could work on the most sublime and momentous of subjects with such little engagement that they could continue gossiping with their acquaintances while still painting. For that reason he considered such men to be mere artisans and strangers to the inner sanctum of art. He himself, when he painted, was always so vitally involved in his subject that he experienced the feelings and emotions in himself which he wished to portray, and unconsciously reacted in accordance with them. Sometimes, when he had a tragic figure in mind, suppressed moans and lamentations would be heard coming from his workroom; or if he was to paint a jolly face, he would be cheerful and talk animatedly to himself. For that reason he painted in a secluded room, to which he admitted no one, not even any of his pupils, so as not to be interrupted in his ecstasies or be laughed at as a fool. In his younger years it once happened that he was experiencing such a moment of rapture when a most touching incident occurred. The excellent Annibale Caracci had just come to visit him, but when he opened the door he saw him standing in a rage in front of his easel, full of fury and anger, and making threatening gestures. He stopped at the door and saw that his friend was working on his picture of the martyrdom of Saint Andrews and was just painting a scornful mercenary who was threatening the apostle. Motionless, he watched him for a time, his

heart full of joy and amazement. Finally he could restrain himself no longer and, uttering a cry of gratitude, he ran and, with pounding heart, threw his arms around his neck.

"This Annibale Caracci was himself a most splendid and energetic man, who sensed deeply the silent grandeur of art and deemed it better to produce great works of his own than to juggle with pretty and flippant words on the subject of other great artworks. His brother Agostino, on the other hand, was not only an artist, but a fashionable man of the world, a man of letters and writer of sonnets, who liked to indulge in long and embroidered speeches about art. On one occasion, when the two of them had returned from Rome and were once more sitting and working in their academy in Bologna, this Agostino began to describe at great length the remarkable antique sculpture of Laocoön and his sons, and to highlight all its peculiar beauties in the most elegantly turned phrases. Now, when his brother Annibale stood by quite unmoved and distant, as if he did not understand what was being said, Agostino became indignant and asked whether he did not feel any of this. Annibale was deeply vexed. Without a word, he took a piece of charcoal, walked over to the wall and quickly, from memory, sketched the outline of the entire Laocoön group so accurately and faithfully that an observer would have thought that he had the original before his very eyes. Then he stepped back from the wall with a smile—but all those present were astonished, and Agostino admitted defeat, acknowledging him as victor in the competition."

When the stranger had told these stories, I raised some other subjects and asked him, among other things, whether he knew any tales of boys who from their early

youth had possessed an especial propensity for painting.

"Oh, yes!" the stranger said with a smile. "There are reports of several boys who were born and brought up in wretched circumstances and who rose to be artists as if they had been called upon by Heaven. Several examples occur to me. One of the very earliest of Italian painters, Giotto, was in his boyhood nothing more than a shepherd who looked after the sheep. He used to amuse himself by sketching his sheep on rocks or in the sand. Cimabue, the father of all painters, once came upon him at this pastime and took him home with him, after which the boy soon surpassed his teacher. If I am not mistaken, quite similar stories are also told of Domenico Beccafumi and of the skillful sculptor Contucci, who when he was a boy modeled in clay the cattle which he had to drive out to pasture. So, too, the famous Polidoro da Caravaggio was at first nothing more than a lad who carried mortar for the masons building the Vatican. While at work, however, he zealously watched Raphael's pupils, who happened to be working there at the time, developed an irresistible desire to paint, and learned very quickly and eagerly. Ah, yes! and another charming example occurs to me, namely the old French painter Jacques Callot. As a boy he had heard much about the splendors of Italy and, since he loved drawing above all else, was possessed by a raging desire to see that glorious land. As a boy of eleven years, he secretly ran away from home without a penny in his pocket and headed straight for Rome. He soon had to take to begging, and when he encountered a band of gypsies on his way he joined them and journeyed on foot with them to Florence, where he really did become a painter's apprentice. Then he went to Rome, but here he was seen

by some French merchants from his hometown who knew
of the distress and anxiety of his parents on his account
and forced him to return home with them. When his
father had him home again, he tried to force him to apply
himself to his studies, but that was all wasted effort. In his
fourteenth year he ran away to Italy for a second time,
but it was his misfortune that he had to run into his elder
brother in the street in Turin, and he dragged him back
to his father once more. Finally his father saw that noth-
ing was of any avail and now voluntarily gave him per-
mission to go to Italy for a third time, where he did in
fact develop into a capable artist. He must have enjoyed
the special protection of Heaven, for despite all his boy-
hood peregrinations he had never been in any danger and
had retained all his purity of soul. Another remarkable
thing about him is that as a boy he always used to pray to
Heaven for two things: namely that, no matter what he
might become, he might distinguish himself before all
others in his work, and that he might not live beyond his
forty-third year. And what is wonderful is that he did in
fact die in his forty-third year."

The old priest had told these stories with great sym-
pathy. Then he walked up and down reflectively, and I
could see that he was having pleasant dreams of walking
around among those many painters of old. I gladly left
him to his reflections and was happy at the thought that
he would think of more stories yet, for his memories
seemed to be coming more and more to life for him.
And after a short time he did indeed begin again, as fol-
lows:

"A few other charming anecdotes occur to me which
bear twofold testimony to what a mighty deity art is for

the artist, and to the power with which it dominates him.
—There once was an old Florentine painter by the name
of Mariotto Albertinelli, an enthusiastic artist, but a most
restless and intemperate man. The uncertainties and effort
involved in studying the mechanical aspects of art, and
the hateful hostility and persecution which he suffered at
the hands of his rivals finally so exasperated him that,
hedonist as he was, he decided to take up a jollier trade
and opened an inn. He was in heartily good humor when
the thing got going and would often say to his friends:
'Look! Isn't this a better trade! Now I need no longer con-
cern myself about the muscles of *painted* figures, but feed
and nourish the *living* instead, and, what is best of all, I
am secure from loathsome persecution and slander as long
as I have some good wine in my barrel.' But what hap-
pened? After he had led this kind of life for a time, the
sublimity and divinity of art impressed themselves so viv-
idly upon him once more that he suddenly gave up his
inn and, like a zealous convert, threw himself back into
the arms of art again.

"The other story is this. As a young man, the famous
and celebrated Parmeggiano happened to be in Rome
painting exquisite things for the Pope at the very time
that the German Emperor Charles V was besieging the
city. The Emperor's troops now broke down the gates and
plundered all the houses, sparing neither great nor small.
Parmeggiano, however, paid no attention whatsoever to
the alarms and tumults of war and stayed calmly at his
work. Suddenly, soldiers break into his room, but what
does he do? He remains steadfast at his easel, working
diligently. Those wild soldiers, who had refused to spare
even temple or altar, were so astonished at the noble

spirit of the man that they did not dare to touch him, as if he were a saint, and even protected him from the fury of others."

"How wonderful all that is!" I cried. "But now let me ask you just one more thing. Tell me whether what I once heard is true, that the earliest of the Italian painters were such God-fearing men that they always painted the histories of saints with sincerity and reverence. Several people whom I have asked have ridiculed me and said that those are merely vain imaginings and pretty legends."

"No, my son," the dear man replied, to my consolation. "Those are not poetic inventions, but the purest truth, as I can prove to you from the old books. Those venerable men, several of whom were themselves priests or friars, devoted the God-given skill of their hands only to religious and holy subjects and endowed their works with the seriousness, piety, and humble simplicity appropriate to objects dedicated to God. They made painting a faithful handmaiden of religion and knew nothing of the vain and ostentatious show of colors of modern artists. Their paintings, in chapels and on altars, inspired the most pious of sentiments in those who knelt and prayed before them. One of those men of old, Lippo Dalmasio, was famed for his exquisite Madonnas, an outstanding example of which Pope Gregory XIII kept in his chamber for his private devotions. Another, Fra Giovanni Angelico da Fiesole, painter and Dominican monk in Florence, was especially famous for his austere and God-fearing life. He ignored all worldly affairs, even going so far as to decline the honor of an archbishopric which the Pope offered him, and always lived quietly, tranquilly, humbly, and alone. It was his custom to pray each time before beginning to

paint. Then he would set to work and paint as Heaven had inspired him, without further analytical or critical reflection. Painting was a holy penance for him, and often when he was at work painting Christ's sufferings on the cross great tears could be seen running down his face. All of that is the absolute truth, and not some beautiful legend."

The priest finished with a very strange tale, which is also set in that bygone period of religious painting.

"One of the earliest painters," he said, "whom we know as Spinello, painted a very large altar panel in his studio for the church of Saint Agnolo in Arezzo. This panel depicted Lucifer and the Fall of the Angels of Darkness: in the air the Archangel Michael, struggling with the seven-headed dragon, and below him Lucifer in the form of an abominable monster. The story is told that he was so preoccupied with this vile Devil that the Evil Spirit appeared to him in that very guise in a dream, asking him in a dreadful voice why he had depicted him as a shameful beast and where he had seen him in this monstrous shape. The painter awakened from his dream trembling in every limb. He tried to cry out for help, but could not utter a sound in his terror. From that time on, he was always half out of his mind and had a fixed, glassy stare. He also died soon afterward. The wonderful painting, however, can still be seen in its old place today."

Soon after this the unknown priest departed and continued on his journey without my even being able to take my leave of him. I was as if in a dream after hearing his fascinating stories, for he had led me into a totally new and wonderful world. Eagerly I inquired everywhere in order to obtain all the life histories of the painters, and

especially the writings of Giorgio Vasari. I read these books with love and zeal, and to my great delight found recorded in them all the histories which the unknown priest had related. It was this unforgettable man who led me to the study of the history of the artists, which provides so much nourishment for the mind, the heart, and the imagination, and for this I owe him thanks for very many happy hours.

Wackenroder

The Remarkable Musical Life of the Tone-Poet Joseph Berglinger

IN TWO PARTS

Part One

More than once I have looked to the past and have garnered treasures from the art history of bygone centuries for my enjoyment; but now my spirit moves me to linger for once in the present and to try my hand at the history of an artist whom I knew from his early youth and who was, indeed, my bosom friend. Alas! you took early leave of this earth, dear Joseph, and I shall not easily find your like again. Yet I will revive my spirits by retracing in my thoughts your inner history from its beginnings, putting together what you often told me at length in happy hours and what I myself knew of your heart; and I will make your story known to those who will have pleasure from it.

Joseph Berglinger was born in a little town in southern Germany. His mother had to depart from the world even as she brought him into it; his father, a man already fairly advanced in years, was a doctor of medicine living in straitened circumstances. Fortune had turned her back on him, and it was only by the sweat of his brow that he managed to fend for himself and his six children (Joseph had five sisters), especially since he now lacked a prudent housekeeper.

This father had originally been a gentle and good-hearted man who desired nothing more than to give assistance, advice, and charity to others as far as his means permitted. After a good deed he would sleep more soundly than usual, and with a heart overflowing with sentiment and gratitude to God, he could long sustain himself on the knowledge of his own kindness, for he loved above all to nourish his spirit on tender feelings. One cannot but be moved to profound melancholy and heartfelt compassion at the thought of the enviable simplicity of those souls who find in the everyday expression of their kind hearts such an inexhaustible source of splendor that this is their Heaven on earth through which they are reconciled with the whole world and can maintain themselves in contentment and serenity. Joseph shared this sentiment wholly when he looked upon his father— but Heaven had ordained that *he* should strive after something nobler still. Spiritual well-being alone was not enough to satisfy him, nor was the mere faithful observance of his earthly duties, such as working hard and doing good. More than this, he wished his soul to exult in a dance exuberant and sublime, and to sing hymns of joy to Heaven from which it had come.

Yet there was another side to his father's character too. He was an industrious and conscientious doctor who, his whole life long, had derived pleasure only from knowing the strange things which are hidden in the human body and from the detailed investigation of all the woeful infirmities and maladies to which mankind is subject. As often happens, the passionate pursuit of these studies had in the end become a slow, nerve-dulling poison, flowing through every vein and gnawing through many a responsive chord of his heart. This was aggravated by ill humor resulting from his calamitous poverty and finally by old age. All of this preyed upon the original goodness of his heart, for in a sensitive and weakened soul everything that he does goes over into his blood, transforming his inner self without his knowing it.

The old doctor's children grew up at home like weeds in a neglected garden. Joseph's sisters were either sickly or of unsound mind and led a pitifully lonely existence in their dark little room.

No one could have fitted into this family less well than Joseph, who lived in a realm of grand imaginings and exalted dreams. His soul was like a delicate little tree sprouting forth chastely from between the cruel stones of some wall or ruin where a bird had dropped its seed. He was always solitary and withdrawn, delighting only in his inner fantasies, so his father took him to be a little feebleminded and backward like his other children. He loved his father and sisters sincerely, but more than anything he valued his inner life, and he kept it secret and hidden from others, as one would conceal a jewel box and entrust its key to no one.

From his earliest years his greatest joy was music. Occa-

sionally he would hear someone play the piano, and he also played a little himself. Little by little, through frequent enjoyment of this pleasure, he developed his sensibilities, but in such a way that his inner life became the purest music, and his soul, captivated by this art, was forever hovering in the treacherous twilight zone of poetic sentiment.

A decisive turning point in his life was occasioned by a visit to the residence of a prince-bishop where he was taken for a few weeks by a wealthy relative who lived there, and had taken a fancy to the boy. Here he was in very Heaven. His soul was enraptured by a thousand sweet melodies and fluttered about like a butterfly in the warm air.

He especially loved to visit the churches and to listen to the sacred oratorios, canticles, and chorales with their rich concord of horns and trumpets resounding under the lofty vaults, and he would then often fall to his knees in humility and heartfelt devotion. Before the music began, as he stood there in the pushing, whispering throng, the hum of common life around him would remind him of nothing so much as the incoherent discord of a crowded fairground, numbing his mind with its worldly vanity and triviality. Expectantly, he would await the first sound of the instruments—and when it came bursting forth, mighty and sustained, shattering the dull silence like a storm from Heaven, and when the sounds swept over his head in all their grandeur—then it was that his soul spread great wings, as if he were rising up from a desolate heath, as if the curtain of dark cloud were dissolving before his mortal gaze, and he were soaring up to the radiant Heavens. Then he would hold his whole body still and motionless,

fixing his eyes unmoving on the floor. The present re-
ceded, and his very being was purged of all that earthly
ballast which is very dust upon the polished mirror which
is the soul. The gentle tremors of the music penetrated
every nerve, its twists and turns conjuring up a myriad of
images before him. On listening to joyous and uplifting
anthems to the glory of God, for instance, he would often
clearly visualize King David, in crown and flowing regal
robes, dancing and singing praises before the Ark of the
Covenant; he would witness all his ecstasy and his every
movement, and his heart would leap for joy within him.
A thousand sleeping sentiments were aroused and traced
wondrous, ever-changing patterns in his breast. Finally, at
certain moments in the music, it seemed as if his soul were
illuminated by a divine radiance. He would suddenly feel
much wiser, as if he were looking down upon the earth
and its teeming millions with a visionary's eyes and with a
certain noble and serene sadness.

This much is certain: when the music had ended and he
left the church, he felt purer and nobler. His whole being
was still flushed with the spiritual wine which had intoxi-
cated him, and he looked at all the passersby through new
eyes. If he then chanced to see some strollers stop to chat
or laugh or exchange news, they would make a most pecu-
liar and repulsive impression on him. He would think:
"You must never, ever descend from this sublime poetic
ecstasy, and your whole life must become an endless mel-
ody." If he then went to his relative's home for his midday
meal and happened to enjoy himself in a group of normal,
happy, jovial people, he would become despondent that
he had sunk so soon back into prosaic existence and that
his intoxication had passed like a cloud caught for only a

fleeting moment in the radiance of the sun. This bitter conflict between his inborn ethereal striving and the claims of everyday life, which daily force all men down out of their reveries, tormented him his whole life long.

When Joseph was in a crowded concert he would sit down in a corner without glancing at the glittering audience and would listen with the same reverence as he did in church—just as silent and motionless, and with his eyes fixed on the floor as before. Not the slightest note escaped his attention, and at the end he was limp and tired from exertion and concentration. His impressionable soul was a mere plaything of the notes. It was as if it had become detached from his body and were ranging about more freely, or as if his body had itself become spirit, so gently and easily did the lovely harmonies envelop his whole being, the slightest movements and deviations in melody leaving their imprint on his tender soul. On hearing the full orchestra playing gay and spirited symphonies —this kind of music he loved above all—he would often visualize a merry chorus of youths and maidens dancing on a smiling meadow, skipping back and forth, with couples sometimes stepping forward to mime together, then merging back into the happy throng. Many passages were so vivid and engaging that the notes seemed to speak to him. At other times, the notes would evoke a mysterious blend of joy and sorrow in his heart, so that he could have either laughed or cried. This is a feeling which we experience so often on our path through life and which no art can express more skillfully than music. With what rapture and astonishment he would listen to a composition which opens with a tune gay and sprightly like a brook, a tune which then, imperceptibly and mysteriously, slows down

into sad meanderings, bursting out finally in loud passionate sobs, or rushing along with a frightening roar as if through a wild gorge. All these varied feelings would now call forth corresponding sensuous images and new thoughts in his soul. That is the marvellous gift of music, which affects us the more powerfully and stirs all our vital forces the more deeply, the vaguer and more mysterious its language is.

At last Joseph's happy days in the bishop's residence had come to an end, and he had to return to his hometown and to his father's house. How sad the journey home was! How miserable and depressed he felt to be back with a family whose main aspiration in life was to eke out a pitiful living, and with a father who had so little sympathy for his inclinations! His father despised and execrated all the arts as handmaidens of wantonness and the passions, and as flatterers of the upper classes. He had long disapproved of his son Joseph's attachment to music and now, as this love grew ever stronger in the boy, he made a sustained and determined effort to turn him against a destructive inclination for an art, the practice of which was not much more than idleness and whose object was merely the gratification of man's sensuous cravings. He wished to win him over to medicine as the science most beneficial and useful for mankind. He spared no effort to instruct him personally in the fundamentals of this science, and he also put textbooks in his hands.

This was a most painful and agonizing situation for poor Joseph. Quietly he suppressed the enthusiasm in his breast, so as not to offend his father, and he tried to force himself to learn a useful science on the side. But that provoked an endless war in his soul. He would read one page

of his textbook ten times over without understanding it. Secretly his soul continued to weave its fantastic melodies. His father was most concerned.

His ardent love of music quietly overcame all attempts to smother it. If a few weeks passed without his hearing any music, he would become genuinely disturbed. He felt his sensibilities atrophy and an emptiness take possession of his soul, and he was consumed by longing to experience again the inspiration which music brings. At such times even vulgar musicians at festivals or church fairs could inspire in him, with their brass instruments, feelings of which they themselves had no notion. And any time a good concert was to be heard in a neighboring town he would dash out to it, burning with desire through storms of wind, rain, or snow. Scarcely a day passed but he recalled nostalgically those glorious weeks spent in the bishop's residence, and he savored again in his memory the exquisite things he had heard there. He would often repeat to himself the sweet and moving words which he knew by heart from the very first oratorio he had heard there, and which had made a profound and lasting impression on him:

> Stabat Mater dolorosa
> Juxta crucem lacrymosa,
> Dum pendebat filius:
> Cujus animam gementem,
> Contristantem et dolentem
> Pertransivit gladius.
>
> O quam tristis et afficta
> Fuit illa benedicta

> Mater unigeniti:
> Quae moerebat et dolebat
> Et tremebat, cum videbat
> Nati poenas inclyti

and so on.

But alas! when it happened that such moments of ecstasy, induced by ethereal reveries or by the intoxicating delight of a splendid concert he had just heard, were interrupted by his sisters quarreling over a new dress, or by his father's inability to give his eldest daughter enough housekeeping money, or by his father telling of some pitiful and wretched patient, or by a crippled old beggar woman coming to the door, unable to protect herself from the winter's frost with her rags—alas! there was no feeling in the world so bitter, terrible, or heartrending as the feeling by which Joseph was then torn. He would think: "Dear God, is this how the world really is? And is it Your will that I should mingle with the vulgar throng and participate in their baseness and misery? It seems to be so, and my father is forever preaching that it is man's duty and destiny to share in all that is human, to dispense advice and charity, bind hideous wounds, and heal loathsome illnesses. And yet an inner voice cries out: 'No! No! You are born for a higher and a nobler destiny.'" Often, for hours on end, he would torture himself with such thoughts, unable to find any way out of his dilemma. Yet almost before he knew it, the vile images which seemed to drag him down into the mire of this earth would vanish from his soul, and his spirit would be reveling freely again in the breezes.

Gradually he became wholly convinced that God had

set him on the earth to become a musical genius, and at times he imagined that Heaven would raise him to even greater heights of glory on account of the depressing restrictions and privations which he had to suffer in his youth. Many will think it fanciful and exaggerated, but it is the plain truth when I say that on an impulse of his passionate heart he would often fall upon his knees in his loneliness and beg God to guide him so that he might one day become a great artist before Heaven and the world. It was at this time, when his blood was often in a turmoil due to his obsession with these ideas, that he wrote several short poems describing his condition or praising his art, and these he set to music in his childish, sentimental way, though he lacked all knowledge of the rules of composition. An example of these songs is given by the following prayer, which he addressed to that saint who is honored as the patroness of music:

> See how bitterly I weep here
> In my solitary chamber,
> > Holy Saint Cecilia!
> See me flee the world's enticements
> To kneel silent here before you.
> > I implore you, hear my prayer!

> The enchantment of your music,
> Which I venerate and worship
> > Has possessed and filled my soul.
> Free my senses from their bondage,
> Let my soul dissolve in anthems
> > Which so sweetly charm my heart.

Let my unskilled fingers call forth
From the mute, resistant harp-strings
　　Feeling, wave on wave.
Let my playing, with your guidance,
Evoke rapture and sweet torment
　　In a thousand human breasts.

Let me once with horns and cymbals
In some vast and crowded temple
　　Sound out a solemn Gloria,
For you and all the saints in Heaven,
And rejoice a thousand Christians,
　　Holy Saint Cecilia!

Make all men open up their hearts,
That through the magic charm of song
　　I may overpower their souls,
That my song may sing your praises,
Charm the world with sweetest concord,
　　And entrance it with delight!

For more than a year Joseph was tormented, and
brooded in isolation over a step which he wished to take.
An irresistible force was drawing his spirit back to the
splendid city which he regarded as his personal paradise,
for he was aflame with desire to learn the fundamentals of
his art there. His relations with his father, however, con-
stricted his heart. His father had not failed to notice that
Joseph was no longer willing to apply himself earnestly
and industriously to his scientific studies and had already
half given him up, withdrawing into the privacy of his
rancor, which increased with his advancing years. He had
less and less to do with the boy. Yet that did not destroy

Joseph's childish feelings. He was forever struggling against his natural inclinations and still could not tell his father what he had to tell him. For days on end he tortured himself, weighing every alternative, but he simply could not escape the dreadful abyss of indecision, and his fervent prayers remained unanswered. That almost broke his heart. The following lines, which I found among his papers, bear witness to the depths of the despondency and suffering which he was then experiencing:

> Ah! what is it that so sore afflicts me,
> Holds me clasped in powerful embrace,
> Charging me to flee my native city,
> Forcing me to leave my father's home?
> Ah! what martyrs, what intense temptations
> Must I suffer through no guilt of mine!
>
> Son of God, I beg You by Your wounds!
> Still this anguished throbbing of my heart!
> Pour your revelation down upon me,
> Lighting up my darkened, downcast spirit!
> Indicate the path which I should follow!
> Show my heart the way it has to take!
>
> If You will not take me to You soon
> Or in nature's bosom grant me rest,
> I must give myself to alien powers;
> Must, in torment, serve that hostile force
> Drawing me from father and from home,
> Must become its victim and its prey.

His anguish grew more and more intense; the temptation to flee to the splendid city grew stronger and stronger. "Will God not come to your aid?" he asked.

"Will He give no sign?" His passion finally reached its
height when, after a domestic disagreement, his father
rebuked him with unaccustomed severity and from then
on encountered him with unremitting hostility. Now the
matter was settled: henceforth Joseph dismissed all
doubts and hesitations. He now no longer wished to
reflect at all. Easter, which was fast approaching, he
would celebrate at home—but as soon as it was over he
would run away.

Easter came and went. He waited for the first fine
morning, when the bright sunshine seemed to invite him
forth with all its charms. Then, at an early hour, he ran
out of the house as was often his custom—but this time he
did not return. His heart pounding with joy, he hurried
through the narrow lanes of the little town. He felt as if
he could jump over everything he saw and leap into the
open arms of Heaven. He happened to meet an old rela-
tive at a corner. "Where are you off to in such a hurry?"
she asked. "Off to fetch vegetables for the family at the
market?" "Yes, yes!" Joseph called back in his thoughts,
running out through the city gates trembling with joy.

Yet when he had gone a short distance over the fields
and looked around, he burst out in a flood of tears.
"Should I turn back before it is too late?" he thought.
But he ran on as if the ground were burning beneath his
feet, and he wept and wept, letting his tears run freely as
if he might rid himself of them in this way. And so he ran
through many an unfamiliar village and past many an
unfamiliar face. The sight of this new and unknown world
restored his courage, and he felt free and strong. He came
closer and closer, and finally—good Heavens! what de-

light!—finally he saw the towers of the splendid city rising up before him.

Part Two

When we next see Joseph, several years have passed, and he has become orchestral conductor in the bishop's residence, where he is living in great magnificence. His relative, who had received him most hospitably, had become the architect of his good fortune, seeing to it that he received a thorough musical education, and with time even reconciling Joseph's father somewhat to the step which his son had taken. Through zeal and industry Joseph had worked his way up, finally scaling the highest pinnacle of success to which he could ever have aspired.

Yet things of the world change before our very eyes. After he had been conductor for a few years, he once wrote me the following letter:

Dear Father,

What a lamentable life this is that I am leading— and the more you try to console me, the more bitterly I feel it.

Ah! when I think back to the dreams of my youth and of how blissfully happy I was in dreaming them! I imagined I would pass through life reveling in uninterrupted fantasies and pouring forth the fullness of my heart in works of art—but how disconcerting and cruel even my first years of musical instruction were! How disillusioned I felt when I peeped behind the curtain of mystery! To think that all melodies (even those which inspired the most varied and often the most marvellous of feelings in me) were

based on one single, stringent mathematical law! To think that instead of flying unrestrained I first had to learn to climb around on the clumsy scaffolding and prison bars of artistic rules and regulations! What torment I had to endure in order first to produce a regularly-constructed work by means of vulgar mechanical scientific reasoning before I could even contemplate expressing my feelings in music! What a tedious expenditure of mechanical effort! And yet, what of it? I still possessed youthful energy and was full of hope for a glorious future! And now? Now my glorious future has become piteous present.

What happy hours I enjoyed in the great concert hall as a boy! When I sat still and unnoticed in the corner, enchanted by all the magnificence and splendor, longing so fervently that one day these listeners might gather to hear *my* works and harmonize their feelings reverently with mine! Now I often sit in this selfsame hall and even direct my works there, but how very different I feel. That I could ever have imagined that these concertgoers, strutting in gold and silk, came together to enjoy a work of art, to enkindle their hearts or offer up their feelings to the artist! Even in our majestic cathedral on the most holy of feast days, when everything sublime and beauteous that art and religion have to offer is forcibly thrust upon their attention—even then these souls cannot be enflamed, so how can one expect them to be so in the concert hall? Unpremeditated feeling for art has fallen out of fashion and become disreputable. To be moved upon experiencing an artwork would be no less strange or ridiculous than

bursting out in verse or in rhyme in a group of friends when one is otherwise normally accustomed to making do with sensible, generally-comprehensible prose. And it is for souls like these that I exhaust my inspiration! For these I spare no effort so that their feelings might be stirred! This is the noble destiny for which I believed I was born!

And when it happens, as it occasionally does, that someone who is not entirely bereft of feeling attempts to praise me or pays me critical tribute or asks me critical questions—then I am always tempted to beg him not to make such an effort to learn from books how to feel. Heaven knows how it is with me: on occasions when I have just enjoyed a piece of music, or some other artwork which has delighted me, and my whole being is full of it, I would like to paint my feelings onto a panel with one single brushstroke, if only one color could express all that I feel. I do not have the ability to express praise in elegantly-turned phrases, and if I were to try I would not be able to put two sensible words together.

There is, of course, some comfort in the thought that in some little corner of Germany which this or that work of mine may reach even long after my death there may perhaps be someone whom Heaven has endowed with such an intuitive understanding of my soul that he will sense in my melodies those very feelings which I had on composing, and which I so much desired to express through them. A fine idea indeed, with which a person can delude himself pleasantly for a while!

Yet what surpasses everything in repulsiveness are

all those other circumstances in which the artist is en-
meshed: all the disgusting jealousies and malicious
intrigues, all the vile and petty practices and deal-
ings, all the subordination of art to the will of the
court. It is all so unseemly and so debasing for the
human soul that it leaves me speechless. It is a triple
misfortune for the art of music that it requires so
many hands before one work may come into being!
I concentrate and exalt my spirit to create one great
work—and a hundred insensitive empty heads all
wish to have their own say, demanding this and that.

In my youth I thought that through music I might
escape all earthly woe, only to find myself now the
more firmly bogged down in the mire. Alas! there can
be no doubt that, stretch our spiritual wings as we
may, we cannot escape the earth, for it pulls us back
with brutal force and we fall again among the most
vulgar of vulgar people.

The artists whom I see around me are pitiful crea-
tures. Even the noblest among them are so petty that
their conceit knows no bounds if one of their works
happens to achieve general popularity. Good Heav-
ens! do we not owe one half of the credit we receive
to the divinity of art itself, the indwelling harmony
of nature, and the other half to the benevolence of
the Creator who gave us the ability to avail ourselves
of the precious gift? Are not all the thousands of
sweet melodies which evoke the most varied senti-
ments in us derived from the one wondrous triad
which is inherent in nature from everlasting to ever-
lasting? What are those melancholy, half-sweet and
half-painful feelings which music mysteriously arous-

es in us if not the mystic interplay of Major and Minor? And is it not to the Creator that we owe gratitude for having given us the skill to stir the human heart by combining these sounds which from the beginning of time have possessed such wondrous affinities with our souls? Truly, it is Art which deserves our reverence, not the artist. The artist is no more than God's feeble instrument.

You can see that my zeal and love for music is undiminished. Indeed, that is the reason why I am so unhappy in this . . . but I will stop here and spare you the vexation of having to listen to my account of all the vileness around me. Suffice it to say that the very air which I breathe is impure. How much nearer I was to my ideal in the innocence of my youth, in quiet and solitude, when I merely enjoyed art instead of practicing it as I do now in the dazzle of fashionable society, surrounded on all sides by silk finery, medals and ribbons, and by the most cultivated and discriminating of men! You must wonder what I would really like most to do. I would like to turn my back on all this culture and flee to the simple Swiss herdsman in his mountains, and join him in his Alpine songs for which he feels homesick no matter where he may roam.

This fragmentary letter will convey some impression of how Joseph felt in the situation in which he found himself. He felt lonely and abandoned amidst the discord of so many unharmonious souls around him. His art was desecrated by the fact that, as far as he knew, it made a vital impression on no one, though to him it seemed to epito-

mize all that should move the human heart. There were many sad hours in which he would despair totally, thinking: "What a strange and peculiar thing art is! Does it possess such a mysterious power for me alone? Is it for all other men no more than a diversion for the senses and a pleasant way of passing the time? What then is art in actual fact if it is nothing for all men and something for me alone? Is it not the most unfortunate of notions to make this art our whole life's goal and occupation, and to indulge in a thousand glorious imaginings as to its sublime influence on the human heart—the sublime influence of this art which in the reality of everyday life fulfills no higher a function than does a game of cards or any other pastime?"

When such thoughts came to him he would take himself for the most extravagant of dreamers to have striven so arduously to become a practicing artist for the benefit of mankind. He hit upon the idea that an artist must create for himself alone, for his own heart's exaltation, or for only one or two others who understand him. And I cannot bring myself to disagree with him entirely.

But I will sum up the rest of Joseph's life briefly, for the memory of it fills me with sadness.

He lived on like this as conductor for several years, and his discontent grew more intense, as did the painful awareness that for all his profound sensibility and all his deepfelt artistic intuition he was of no practical use in the world and much less effective than any common craftsman. He often thought back with melancholy to the pure, ideal enthusiasm of his boyhood years, and also to his father and the efforts which his father had made to train him as a doctor so that he might alleviate the sufferings of

mankind, heal the sick, and so be of some use to the world. "Perhaps it would have been better that way," he would often think.

Meanwhile, his father had become very weak in his old age. Joseph always wrote to his eldest sister and sent her money to help support their father. Yet he could not bring himself to visit his father in person, feeling this to be beyond his powers. His melancholy increased; his life was declining toward its end.

Once, he had produced a new and beautiful composition of his own in the concert hall and for the first time seemed to have left the hearts of his listeners not untouched. General astonishment, restrained applause—which is a far greater compliment than loud applause—gave him the joyful idea that this time he had perhaps been not unworthy in the exercise of his art. He took heart again for new work. When he went out into the street, a girl in the shabbiest of clothes stole up to him and tried to speak to him. He did not know what to say. He looked at her. "Good God!" he exclaimed, for it was his youngest sister in the most wretched attire. She had come from home on foot to bring him the news that his father was dying and wanted urgently to speak to him again before his end. At that, all the melody in his breast was turned to discord once more. Stunned and stupefied, he made ready and left hastily for his hometown.

The scene which greeted him at his father's deathbed I will pass over. Do not imagine that lengthy and tearful mutual explanations were necessary. They understood each other totally without many words being exchanged—for nature seems to mock us in that it is not until such crucial last moments that men understand each other as

they should. Yet Joseph's heart was rent by all that he saw. His sisters were in the most pitiful state. Two had taken a bad road and had run away from home. The eldest, to whom he had always sent money, had squandered most of it and let her father want. Finally, he saw his father die a pitiful death before his very eyes. Alas! how cruelly his poor heart was wounded and pierced to the quick! He provided for his sisters as best he could and returned home where business called him.

For the Easter celebration which was imminent he was to compose a new Easter oratorio, which his jealous rivals were anxious to hear, but he wept bitterly each time he tried to start work on it. He could find no refuge from the anguish of his heart. He was deeply depressed and buried under the dross of this earth. Finally he took a strong hold of himself and stretched his arms out to Heaven in ardent longing, filling his breast with the most sublime poetry and with a loud song of rejoicing. Then, in a flood of miraculous inspiration, but held in the grip of violent emotion, he wrote down music for the Passion which with its insinuating melodies, expressing all the agonies of suffering, will forever remain a masterpiece. His soul was like an invalid who in a prodigious seizure shows greater strength than a man in good health.

But after conducting the oratorio in the cathedral on the holy day with feverish strain and fervor, he felt quite faint and listless. A nervous debility, like an evil dew, fell upon his vital forces. He languished for a time, and died soon afterward in the flower of his youth. . . .

Many a tear I have shed for him, and I am curiously moved when I survey his life. Why was it the will of Heaven that the conflict between his ethereal enthusiasm

and the baseness and wretchedness of earthly existence should so embitter his whole life and should in the end sever forever body from spirit in his divided self?

The ways of Heaven defy all our understanding. Yet let us once more marvel at the diversity of those sublime spirits whom Heaven sends down to us as servants of art. In perfect innocence and artlessness Raphael created works of unsurpassed genius in which we can see Heaven reflected in all its glory. Guido Reni, who lived such a wild gambler's life, painted the gentlest and most pious of pictures. Albrecht Dürer, a simple citizen of Nuremberg, produced the most soulful works of art by dint of mechanical industry and application in the same little room in which his shrew of a wife bickered with him daily. And Joseph, whose harmonious works possess such mysterious beauty, was different from all of these!

Alas! what a bitter irony of fate that it was his very strength, his sublime fantasy, which wrought his destruction! Should I say that he was perhaps born to enjoy art rather than to practice it? Are those men perhaps of happier constitution in whom art works silently and secretly like a veiled spirit, never disrupting their everyday affairs? Or must the man of unfailing inspiration perhaps anchor his exalted visions boldly and firmly in this earthly life if he is to become a genuine artist? Is not this unfathomable power to create perhaps something quite different from and—it seems to me now—something still more wonderful and more divine than the power of the imagination?

The artistic spirit is and must ever remain a mystery for man, and his head swims when he tries to plumb its depths. But it is, too, an object of the highest wonderment, as must be said of all that is sublime on earth

After these recollections of my dear friend Joseph I can write no more. I close my book, and only wish that it may serve to awaken good thoughts in some unknown reader.